RED GROOMS

and

RED GROOMS
and

JUDD TULLY

George Braziller New York

For China Willow

Copyright © 1977 by George Braziller, Inc.
All rights reserved
For information address the publisher:
George Braziller, Inc., One Park Avenue, New York, N.Y. 10016

Library of Congress Cataloging in Publication Data
Tully, Judd.
 Red Grooms and Ruckus Manhattan.
 1. Grooms, Red. Ruckus Manhattan. I. Title.
NB237.G84T84 709'.2'4 76-55130
ISBN 0-8076-0848-3
ISBN 0-8076-0849-1 pbk.

Designed by Antony Drobinski
Printed in the United States of America
by The Press of A. Colish, Mount Vernon, N.Y.
First edition

Contents

Acknowledgments

Hats off to Red Grooms, Mimi Gross Grooms, and the Ruckus Construction Co. for their generous helpings of time and anecdotes. For their herculean patience with my journalistic nitpicking, special thanks to Mimi, Archie and Connie Peltier, Andrew Ginzel, Chip Duyck, Jody Elbaum, Robin McDaniel, Kent Hines, Peter Hutton, David Saunders, and Jill Sternberg.

Bows and curtsies to Anita O'Neill of Creative Time, Inc., and to Pierre Levai and Patricia Gallagher of Marlborough Gallery for their unreserved assistance and cooperation. Additional thanks to Bob Mates for his excellent photographs, most of them taken in a hectic three-day marathon session just before the sets were struck, and to the Marlborough for supplying all photographs of *Ruckus Manhattan* for publication.

A footnote of gratitude to Joel Handorff for timely jabs of inspiration; Gary Thompson for a hard-nosed, eagle-eyed critique of the manuscript; and Gayle Gleason for her exquisite made-to-order architectural photographs. Finally, my personal thanks to George Braziller and editor James Hoekema for making this mad project possible, and to Red Grooms, who recommended me as author.

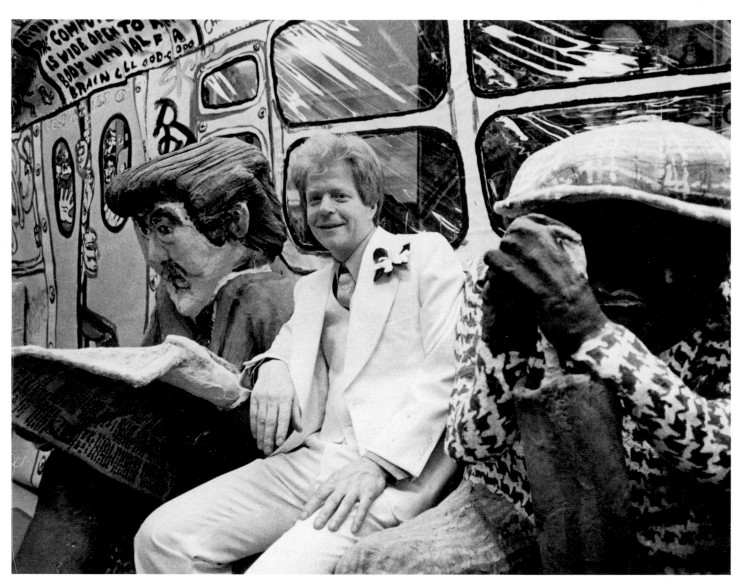

1. Red Grooms seated between passengers on his "Subway" at the May 1976 opening of *Ruckus Manhattan*. Photograph by John Cornell; Copyright © 1976 Newsday, Inc., reprinted by permission.

Introduction

Ruckus Manhattan culminates a thirteen-month collaborative effort by Red Grooms and his multitalented crew of visual mercenaries to build a minutely documented sculptural environment of Manhattan Island, from New York Harbor and Wall Street at the southern tip all the way to The Cloisters, Rockefeller's medieval monument in Fort Tryon Park at 193rd Street. Time and money cut the gargantuan goal of conquering Manhattan midway at the Art Deco complex of Rockefeller Center at 5th Avenue and 50th Street. By that point, however, *Ruckus* had already vanquished the Brooklyn Bridge, the Woolworth Building, and the World Trade Center, to say nothing of Chinatown, 42nd Street, and the Lexington Avenue subway.

Red Grooms describes his 3D wonderworks best in typical Ruckus shorthand slang—"a chicken coop creakiness"—a slapdash approach without blueprints or scale drawings but a finished product that stands up to the tens of thousands of Ruckus revelers who walk through and around the wayward buildings and loony characters of Grooms's "sculptural novel."

Ruckus Manhattan was built for the man in the street, the "white collar coolies" of Henry Miller's *Tropic of Cancer,* not the cultural elite of gallery groupies that dominate the contemporary art scene. The Ruckus works are up-to-the-minute headlines of life in Gotham City, ultra-contemporary portraits viewed from the perspective of a gargoyle jutting out from the terra-cotta skin of the Woolworth Building or a subterranean crocodile dancing in mad abandon in the sewers of the financial district.

First, relax over an informal history of the evolution of the Groomsian Ruckus from burning buildings and traveling puppet shows to Venezuelan intrigue and opening-night blackouts. Marvel at the madcap adventures at the No Gas Cafe and the heart-stopping highjinks of master builders and mad electricians. Contemplate the yards of canvas, the gallons of paint, the seas of celastic and vinyl devoured by this blinking, whirring, groaning behemoth of environmental sculpture.

Then climb aboard the Ruckus roller coaster and see the sights on a guided tour with Alec and Alice in Groomsland. Above all, keep your eyeballs Visine-fresh for the acrobatic antics of *Ruckus Manhattan.*

Red Grooms before the Ruckus

On a slushy December eve in 1959, under the crumbling ceiling of a converted boxing-gym loft on the eastern edge of Delancey Street, Red Grooms, under the grease-painted guise of "Pasty Man," somersaulted from his *Burning Building* stage set into the bug-eyed throes of his audience. At this particular performance the audience consisted of painter Jim Dine, and *Burning Building* spread the newly incubated "Happening" like brush fire through the funky lofts, storefronts, and alleyways of Lower Manhattan.

The ten-minute-long *Burning Building* performance became a multi-media metaphor for the spine-tingling theatrical panache of Red Grooms. "Pasty Man," a good-natured pyromaniac who eludes an absurd Keystone Kopish fireman in the Dada drama, retired to a dusty shelf, only to gestate

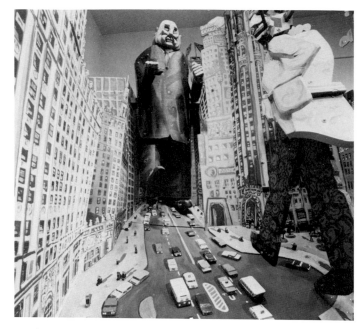

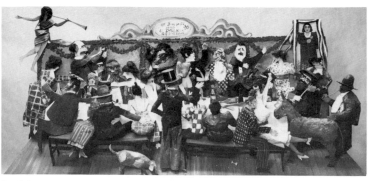

2. (above)
Le Banquet pour le Douanier Rousseau, 1963. 2'8" x 6'9" x 1'4".
Collection Carter Burden, New York.

3. (left)
The City of Chicago (detail), 1968.
12 x 25 x 25'. Art Institute of Chicago
(Gift of Mrs. Maggy Magerstadt-Fisher). Photograph by Jonas Dova-denas, courtesy Rutgers University
Art Gallery, New Brunswick, N.J.

and reemerge years later as the free-wheeling, toe-tapping anarchist, the infamous Ruckus.

According to local legend, Ruckus was the horse that pulled the honeymoon gypsy wagon of Red and his bride, Mimi Gross, on a circuitous route through Northern Italy in 1961. The couple's technicolor La Strada puppet shows spread Ruckus goodwill and spun a spider web of 3D art through the Renaissance-rich towns hugging Florence and Venice.

Forming an unholy alliance with the fresco-laden cathedrals of Northern Italy and the tacky billboard-and-neon jungle art of Manhattan, Grooms began an all-out assault on the rigid flatness of the fifties.

For a brief spell Grooms was identified with a cenacle (to borrow a borrowed term from Tom Wolfe) of Happening makers huddled around the Reuben Gallery such as Jim Dine, Allan Kaprow, Claes Oldenburg, and Robert Whitman, whose existential magic shows placed the spectator in the middle and surrounded him with an environment. It is just as easy, though, to hurtle Grooms backward to the Dada demonstrations of the late teens and early twenties of the century, when Jean Arp and Tristan Tzara would bark at each other simultaneously. For that matter, Grooms's labor of love for Manhattan and his lightning-fast drawing techniques recall Reginald Marsh as in *Why Not Use the "L"* (1930, Whitney Museum), while the terrified faces of *Ruckus* subway riders (Pl. 78) evoke the Abstract Expressionism of Willem de Kooning—a more contemporary comparison for the hard-to-pigeonhole Red Grooms.

It was during this early period that Grooms penned a ragged verse of his own: "Oh, the joys of a woodpile, cardboard, canvas, and glue, and paint." These materials enabled Grooms to "3D" his environments and carry his art to a dimension beyond the academic rectangle. It was building to a spectacle under the Big Top, an affair coupling Red's hero, P. T. Barnum, and the darling of Dada, Marcel Duchamp.

In 1962, Red (age 25) collaborated with photographer-filmmaker Rudy Burckhardt on a cinematic testimonial to George Méliès, the "Jules Verne of cinema." The Ruckus production of *Shoot the Moon* incorporated some of the revolutionary traits of Méliès's work, particularly the far-flung notion that a director combines dramatics, design, painting, sculpture, architecture, manual labor, and mechanics on a hodge-podge palette of poetry and magic.

Méliès's incredible versatility, appetite for work (four thousand productions between 1896 and 1914), passion for showmanship and sleight-of-hand feats formed a perfect model for Red Grooms and his mushrooming Ruckus sensibility.

Grooms's 1963 mixed-media tableau *Le Banquet pour le Douanier Rousseau* (Fig. 2) demonstrated again his sophisticated yet hokey grasp of art history with Picasso and company in the Paris of 1908, a community of artists he would periodically document on paper, cardboard, papier-maché, in dioramas and collage animations.

By the mid-1960s, the Happening had meandered into the Be-In, the Love-In, and finally the Vietnam-In of Central Park pow-wows, and Red Grooms had hopscotched from his own Delancey Street Museum to the Reuben Gallery, the Tibor de Nagy Gallery, and by 1969 the John Bernard Myers Gallery.

Each new project added another layer to his multimedia vehicle that raced from celluloid to cartoon to collage and even hand-cranked, pen-and-ink paper movies mounted in miniature painted projectors. Grooms's locomotive was about to veer westward to the City of Big Shoulders, and works measured in inches would graduate to feet. The real Ruckus was about to begin.

The Spectacle Mushrooms and Travels

Red and Mimi Gross Grooms invaded Chicago in the fall of 1967 to create and install an environmental piece for the Allan Frumkin Gallery. Quickly melting into the Midwestern ambiance of Michigan Avenue boulevard art, the pair found native collaborators, and the whirling-dervish effect of Ruckus cast its devilish spell.

The City of Chicago (1968), a mixed-media environment 25 feet square, was the first of a series of highly documented regional "sculpto-picto-ramas" (Red's invention) of urban life, ultracontemporary on the surface with a staccato burst of historic, often art historical, footnotes (Fig. 3). Reams of preparatory sketches from walking tours, rooftop observatories, photographs, and souvenir-style picture postcards insured the accuracy of the pun-soaked details.

Continuing in his own homespun style of *cinéma vérité*, Grooms used *The City of Chicago* as the ultimate Mélies-inspired set for a new film, a Busby Berkeley spectacular called *Tappy Toes*. It is precisely this concoction of sculpture, painting, architecture, music, and film that flooded and at the same time titillated the art-seeking public.

After a successful installation, *Chicago* was dismantled and shipped to the Venice Biennale of 1968, a trip Grooms would take notes on for future reference in packing and storing the relatively fragile and demandingly mobile "sculpto-picto-ramas." Another sponsor was found (the Smithsonian Institution), and *Chicago* traveled to museums in Lincoln, Nebraska, and Washington, D.C. The piece currently resides in stately storage at the Art Institute of Chicago, a gift from art patron Mrs. Maggy Magerstadt-Fisher.

The Midwest continued its siren call, and Grooms moved on to Minneapolis for *The Discount Store* in 1970 (Fig. 4). This virtuoso pastiche of consumer cannibalism elevated Grooms to a kind of carpetbagging artist in residence—a Dada-flavored Walt Disney. Red and Mimi met the local artist couple Archie and Connie Peltier and established a collaborative relationship that would catapult them via a nonstop roller coaster to Cape Canaveral, Caracas, Manhattan, Nashville, Dallas, Fort Worth—wherever the Ruckus had an idea, a sponsor, a show of shows; always grabbing lots of media coverage and not the kind limited to textbook-style art criticism.

Leaving the Midwest for a refueling stop in Manhattan, Red turned off the collaborative juices for a while and plunged into an intimate series of lithographs loosely titled *No Gas*. This work would turn out to be a tantalizing glimpse of a future Ruckus rumble, a pot shot at the all-star, big-time madness of Manhattan. But first, some words from the outer-space techno-Disneys of NASA.

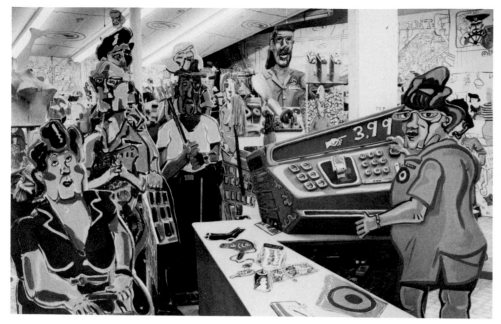

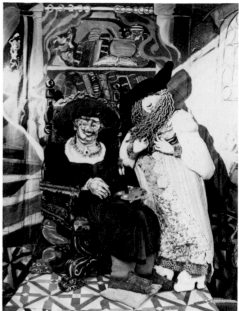

4. (above left)
The Discount Store, 1970.
12 x 25 x 25'. Collection Mimi and
Red Grooms, New York. Photograph
courtesy Rutgers University Art Gallery, New Brunswick, N.J.

5. (above right)
Mr. and Mrs. Rembrandt, 1971.
9'7" x 10' x 3'5". Tennessee Botanical
Gardens and Fine Arts Center, Nashville (Gift of Mr. & Mrs. Ervin M.
Entrekin and Mr. & Mrs. Walter
Knestrick).

Matching Norman Mailer in visual verbosity and intensity, Grooms's 15-foot-high studies of the 1971 moon-probing astronauts of Apollo 15 demonstrated that geography, terrestrial or otherwise, could not hamper the panoramic, sharpshooter eye of Red Ruckus.

Installed like a 13 x 30 x 15' glove in Frank Lloyd Wright's Guggenheim Museum for the "Ten Independent Artists" show of 1972, *The Astronauts* stood up to the colossal organic sweep of Wright's anti-rectangular jigsaw, an unusual feat.

Squeezed between the Moon Walk and a fall 1973 retrospective installed at the Rutgers University Art Gallery and the New York Cultural Center, Red dived into his art-history cauldron and sculpted his canvas, fabric, wood, and acrylic rendition of Mr. and Mrs. Rembrandt (Fig. 5), who joined Picasso, Gertrude Stein, Cocteau, Matisse, Gloria Swanson, and spaceman Walter Cunningham in Grooms's down-home sculpture garden, all bopping to the ragtime beat of impresario Ruckus. *Chicago, The Discount Store* and *The Astronauts* appeared under the same roof for the first time at the Rutgers retrospective, and the accompanying installation extravaganza would bring tears to the eyes of any god-fearing, dues-paying, overtime-killing union man.

As Ruckus grew in cubic feet and man hours multiplied into an inflation-guzzling enterprise, the apprehensive voice of moderation was washed out by the tumult of surging crowds and carny-style entertainment reviews. Like a Broadway show (perhaps Robert Wilson's *Letter to Queen Victoria*) the lights, stage paint, props, and backdrops were made to dazzle the collective eye of the production. No expense was spared. Time and stage space were the only villains.

Reeling from six months of installations, restorations, and take-downs for the Rutgers and Cultural Center exhibitions, the panting Ruckus team was invited to exhibit in South America by the new Museo de Arte Contemporaneo in Caracas, Venezuela. Six cargo containers of Ruckus freight (150 boxes) were shipped to Caracas, and the Groomses and Peltiers flew first class to a politically tense capital in the spring of 1974.

The new twenty-story cultural complex lacked a freight elevator, and architectural steel-and-glass partitions had to be temporarily removed so that a winch could haul the Ruckus through the windows. Aside from jittery militiamen with American M-16's and scattered complaints that Red Grooms was a CIA agent, the Caracas show was a huge success. The museum claimed attendance of 300,000.

Flying back to New York City on a wave of exuberance, Red and Mimi waited for their slow boat from Caracas. No longer represented

by the John Bernard Myers Gallery, Red was an unattached "free agent." Much to his horror, his precious cargo was held up on a Brooklyn dock by suspicious customs and shipping agents. Dope-sniffing dogs were called out, and holes were drilled into the customized wood containers. The delay blossomed into a $17,000 pay-or-leave-it ultimatum. The loopholed Caracas agreement was a one-way ticket, and Red had to dig deep into his personal reserves and then barter a painting to reclaim his work.

Financial fiasco was not a new phenomenon for Red, and before he returned to ringside he daydreamed about huge empty spaces he would fill with unlimited materials for his pulsating pictoramas, aided and abetted by a coven of collaborators. Manhattan was on his mind while unrelated cultural and economic forces gravitated to his front door.

Creative Time Flies By

By the fall of 1974 Red was preparing for a new one-man show of gouaches, drawings, and prints at the Brooke Alexander Gallery. In another part of town, in a largely unrented but award-winning skyscraper designed by I. M. Pei, a work in progress, sponsored by Creative Time, Inc., was being installed. The project, *Sail*, by Anne Healy and Jim Burton, was mounted in a cavernous glass-enclosed "storefront" space, 80 feet square, at 88 Pine Street in the financial district. Red went to see the show and immediately swooned over the open space and 30-foot-high ceilings.

The showman's turbine began to steam and scheme, and diaphanous images of new Ruckus creations floated through the polychromatic video waves of Grooms's revved-up imagination. Before a stampede of ghoulish dollar signs smothered his reverie, Red contacted Anita O'Neill, director of Creative Time.

A nonprofit organization supported in part by administrative grants from the National Endowment for the Arts and the New York State Council on the Arts, and constituted to engage artists to create and display large-scale works of art in publicly accessible spaces donated by the business community, Creative Time was the providential tonic for an ailing Ruckus.

Anita O'Neill arranged a meeting between Grooms and Morley Cho, board member of Creative Time and president of Orient Overseas Associates, the owners of the Pine Street office tower. Mr. Cho was impressed by Red's work at Brooke Alexander, and Ruckus was presented a rent-free key to the 6,400 square feet of virgin studio space at 88 Pine.

Christmas 1974 rolled by, and Red had cut his free-agent strings to join the international artistic elite at Marlborough Gallery on 57th Street. Marlborough mavens Frank Lloyd and Pierre Levai were backing Grooms in his dream to end all dreams—a *Ruckus Manhattan*, a rainbow pano-picto-rama of the sights, sounds, smells, and shapes of America's biggest melting pot.

With initial seed money secured and year-long access to unencumbered space guaranteed, Red and Mimi hitched up the Ruckus wagon and began a new odyssey into the architectural playland of downtown Manhattan. The script was slate-board clean. The director called for action.

In the spirit of *Chicago, The Discount Store,* and *The Astronauts,* preliminary sketches and Polaroid photographs of selected targets were made during marathon hikes through the Wall Street area. Mimi Gross Grooms, Manhattan born and bred, led these search-and-imbibe missions, often on the sturdy antique seat of an English bike. Red

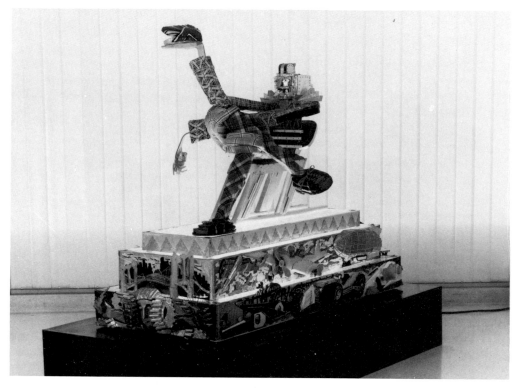

6. *The Minister of Transportation*, 1974. 4'5" x 3'2" x 5'8". Marlborough Gallery, New York.

wired Minneapolis for comrades Archie and Connie Peltier, and a carpentry-hungry ensemble of furry freak brothers, Fred Klein, Dan Kingerly, and Kent Hines, were signed on to the rococo Ruckus bandwagon.

Instinctual engineers Andrew Ginzel and Charlie Powell had joined Red six months earlier on a collaborative venture, an Art Deco wedding-cake-tiered sculpture titled *The Minister of Transportation* (Fig. 6). The Minister, seated in a polished-metal Art Deco chair with his orange plexiglass arm extended holding an open polychromed cigarette case, was a prototype for *Ruckus Manhattan. Transportation Man's* wrist sported a functioning electric alarm-clock wrist watch, and the cigarette protruding from his lips contained optical fiber that accented the red plastic tip of his smoke. The piece, mounted on a black formica base, combined multiple materials (rippled plexiglass, tin, copper, rubber, fabric, etc.) and flaunted Manhattan's boulevards and piers, airways and bridges.

There are no blueprints to a Ruckus work. It starts and never stops. Springtime on Pine Street became a goldfish bowl of mayhem, visible to the infatuated gawkers who pressed their collective noses against the sparkling glass panels of 88 Pine. Office workers on lunch breaks would feast on the helter-skelter boogie of blue-jeaned, T-shirted wizards, sawing, buzzing, scurrying, sketching, sizzling to the tune of Ruckus Gesamtkunst.

The drawing team of Red and Mimi Grooms was amplified by a brigade of painters, welders, wire screeners (see Pl. 7), mechanics, electricians, carpenters, plasterers, fabric seamstresses, and film documenters—a sweatshop of art in process.

Creative Time scheduled a *Ruckus Manhattan* opening for November 20, 1975. Marlborough Gallery would stage the second phase of *Ruckus* in May of 1976. Groggy with deadlines and malnourished from the fast-food haunts of Wall Street, the Ruckus crew set up a "No Gas Cafe" on the premises of Pine Street, and creative caterers Connie Peltier and Jody Elbaum got the cold cuts nuzzling in hero-sized sandwiches for the ravenous sculpto-pictoramists. Day and night, the crew toiled over the grimmest fairy tale of all time—the clock just wouldn't stop. Manhattan had to be built. The public was waiting.

Pine Street

To get a grasp of the voracious appetite for materials *Ruckus* demanded, consider the ritualistic shopping spree Red and Archie would conduct daily on Canal Street after an early breakfast at Chock Full O' Nuts. Armed with a wad of greenbacks, the dynamic duo would pop into a bazaar-style hardware store and, under the beaming gaze of the "Nuts & Bolts" proprietor, scoop up hacksaw blades, boxes of pop rivets, drill bits, scads of brads, washers, pan-head screws, and spaghetti trails of extension cords. A swivel of the head would reveal another sorely needed commodity—aerosol spray-paint cans—and the display rack would be picked clean. Red and Mimi were always going to the bank.

The little stuff was gobbled up and the big items would yap for attention. Pearl Paint on Canal Street, the Bloomingdales of the downtown abstract denim set, would be raided with the same frequency. Mat knives, staple guns, staples, dozens of rolls of sculpture wire, sheets of plexiglass and foam core, and rolls of celastic. (Celastic is a plastic, canvaslike fabric that when dipped in acetone becomes limp like wet kleenex, yet quickly dries to a rock-hard, waterproof state—an unbeatable combination for the lightning works of *Ruckus Manhattan*.) And the paint! Don't forget the rivers of paint, the caseins, acrylics, enamels, undercoatings of gesso, and waterproof overcoatings of rhoplex. First-class stuff. Built to last, built with the idea that some benefactor-patron-gonzo collector would purchase these Ruckus objects. Built with the queasy notion that thousands of viewers would walk through and around these pieces.

Lumber would be ordered for the whining, ear-piercing howl of the circular and band saws. A truck would deliver a load, and $1,500 would disappear into the chasm of Wall Street, the skeleton of the Woolworth Building, the base of the World Trade Center, the foundation for the Staten Island Ferry.

And the steel for the Brooklyn Bridge and the vinyl for the vistas of glass-skinned skyscrapers that proliferate along Broadway, William, Broad, and Wall Streets! To the bank. Back to the bank. To the fabric loft on Canal Street for the soft sculpture, clothing for the foam-padded citizens of *Ruckus*. And Friday, payday, the crew, the ever-expanding crew, received their wages, which at peak production time reached a whopping aggregate sum of $65 on the hour, day and night. The deadline was closing in.

On the eve of the 88 Pine *Ruckus Manhattan* opening, a main circuit burned out, and *Ruckus* (not to mention the entire building) was plunged into darkness. Because of complex electronic security safeguards for the ground-floor bank, it was impossible to gain access to the basement or start repairs before morning. The scent of catastrophe flitted through the air and taunted the caffeine-crazed crew members. Like a high-wire act in the circus or the lion tamer with his head stuck in the jaws of the beast—or more specifically, like the death-defying tightrope walk of Philippe Petit ("If I see three oranges I have to juggle") across the chasm between the towers of the World Trade Center (Pls. 21, 27)—*Ruckus* was always riding a tightrope of disaster.

The show ran like crazy on a limited three-hour-per-day schedule, attracting 50,000 visitors in forty-six days. The four-star final of the *Daily Ruckus* newspaper (published by Creative Time) was a graphic diary of the collaborative cartoon-carny environment of the 22-member crew (Figs. 7-9). Brief, theater-style biographies of crew members and collage-montage photographs accompanied by puzzles, cartoons, editorials, "Rooters News" dispatches, and tributes to the show's sponsors and supporters covered the issue.

7–9. Excerpts from the *Daily Ruckus*, only issue (November 1975). Copyright © 1975 Red Grooms and Creative Time, Inc.

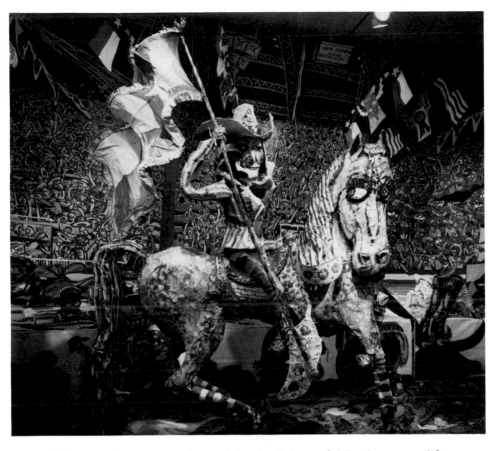

10. *Rodeo*, 1976. 16 x 100 x 30'. Fort Worth Art Museum, Texas. Photograph by Bob Wharton, Fort Worth.

To insure documentation of the building of *Manhattan* a 16mm Bolex movie camera would be on constant duty, available to the pell-mell trail of Ruckus cinematic journalists. Jacob Burckhardt (Rudy Burckhardt's son) devised a "goon" attachment (intervolumeter) for the camera so that a mechanical "cameraman" would click off stop-action time-lapse frames of *Ruckus* in progress, where progress is the most important product.

Phase I of *Ruckus Manhattan* closed on January 20, 1976. Pine Street continued as a studio for the welding of the Brooklyn Bridge and as a general storage area for the May opening of the Marlborough phase. Before the Brooklyn Bridge project and Phase II began, however, *Manhattan* went into a brief limbo, and the action shifted to Red's studio on Walker Street for a showdown at the Ruckus Corral.

Fort Worth Interlude

The Fort Worth Art Museum commissioned Grooms and Company to create *The Great American Rodeo* smack dab in the middle of *Manhattan* madness. In celebration of their 75th anniversary and a Texan-sized salute to the Bicentennial, the museum, with a grant from the Texas Commission on the Arts and Humanities, commissioned eleven major American artists—painters, sculptors, photographers, and video artists—to interpret and document an annual event in Fort Worth, the Fat Stock Show and Rodeo.

While Pine Street blitzed the general public, a secret platoon of Ruckus demons feverishly assembled the 16 x 100 x 30' *Rodeo* constructed out of sculpture wire, celastic, acrylic, canvas, and burlap in the bronco-busting record time of six weeks (Fig. 10). Fourteen canvas figures of cowboys and belles careened about the Coliseum to gape at a yellow, 16-foot-high snorting hurricane, sporting 6-foot-long horns of Brahma Bull, torturing a lone death-defying rider. In typical Groomsian tradition, technicolor footage recorded the construction, installation, and crowd-thronged exhibition of the cowpoking masterpiece.

15

57th Street

The Great American Rodeo traveled on to the Colorado Springs Fine Arts Center, but Red Grooms and his Dry Gulch Gang loped back to Manhattan for another herculean effort. Phase II was uncorked after a frantic week of coloring in consecutive animation drawings for the *Ruckus Rodeo* film. Construction began on the Brooklyn Bridge at 88 Pine, while the Subway, Girls Girls Girls, Pimpmobile, Porno Bookstore, and Chinese Cooks took off at Red's Walker Street studio. The atmosphere was strictly pressure-cooker tense. The show must go on. And it did.

Enter logistics and the Ruckus-inspired nightmare of transporting the goods from 88 Pine and 85 Walker to the glistening expanse of Marlborough Gallery on 57th Street. Kent Hines, an early master builder on the World Trade Center Towers, wrestled with flatbed trailer trucks, cranes, narrow doors, nasty spring weather, mounting bills, and the ultimate sea-sickening question—where do you put all this stuff? Starting from a blueprint of Marlborough Gallery's interior and outdoor sculpture-garden space, a new layout for the slapdash, jigsaw puzzle painfully materialized. Pixilated footage of 500-pound plaster Subway figures on salmon-colored benches, dangling in midair, suspended by the delicate controls of the "Astro Hilift" crane operator, are preserved on Ruckus Celluloid. The ever-present gaping crowds, clogging the high-priced pavement on 57th Street, succumbed to the infectious fascination of the maestro-magician of Grooms tunes.

Over 100,000 visitors toured Phase II of *Ruckus Manhattan,* every adult paying a dollar for the benefit of the Citizens Committee for New York City, a nonprofit group of civic vigilantes headed by then *Newsweek* editor-in-chief Osborn Elliott and dedicated to improving the quality of life for beleaguered Gothamites. (On March 16, 1977, recently appointed Deputy Mayor Osborn Elliott presented the Brooklyn Museum with the "Dame of the Narrows" ferry—a gift from the Citizens Committee for New York City, which purchased the sculpture from Marlborough Gallery for $45,000.) During the Democratic Convention in July 1976, entire state delegations paid their respects to *Ruckus Manhattan,* and newspaper, radio, and TV crews never tired of splashing *Ruckus* over their media ouija board. Red Grooms became a cultural hero, and *Ruckus* curtsied to an avalanche of bravo reviews.

Never before had the hordes of Gotham invaded the elitist gallery corridors of 57th Street. Marlborough was like Barnum & Bailey at Madison Square Garden. Kids and grown-ups swarming over each Ruckus creation like a bevy of used-car buyers kicking away in mad abandon at the proverbial Ruckus tire. Lines formed for the Subway, and kids squealed at the Madame Tussaud realism of the strap-hanging monsters. Like an expedition to a distant planet's Coney Island, clusters of citizens climbed up the twisting escalator of the wooden World Trade Center for a glimpse of Mexico and Nashville on the plexiglass observatory panels.

Oohs and ahhs cascaded across the sculpture garden (usually reserved for the David Smiths and Henry Moores) at the incredible sight of PATH trains snaking out of the Trade Center Terminal on 45 feet of shiny-steel railroad tracks. The *Ruckus* customized cars ran parallel to the fish bones and rusted tin-can-strewn Westside Highway landfill, passing through the chest of a bizarre creature with sculpted sun-bleached coke cans for a face—a hard-hat construction worker, a fatality from the Trade Center or perhaps an anthropological specimen from another age, a prehistoric Cardiff man (Pl. 29).

Despite constant surveillance, damage was a daily occurrence. Supercharged grade-schoolers would dash across the floor boards of the Staten Island Ferry and crash into the nylon waves of the East River. There was no stopping them. It was too exciting.

11. (opposite) *Ruckus Manhattan* under construction: Grooms lays out "Wall Street" with magic marker and sketch pad. Photograph © 1976 by Fred W. McDarrah, New York.

16

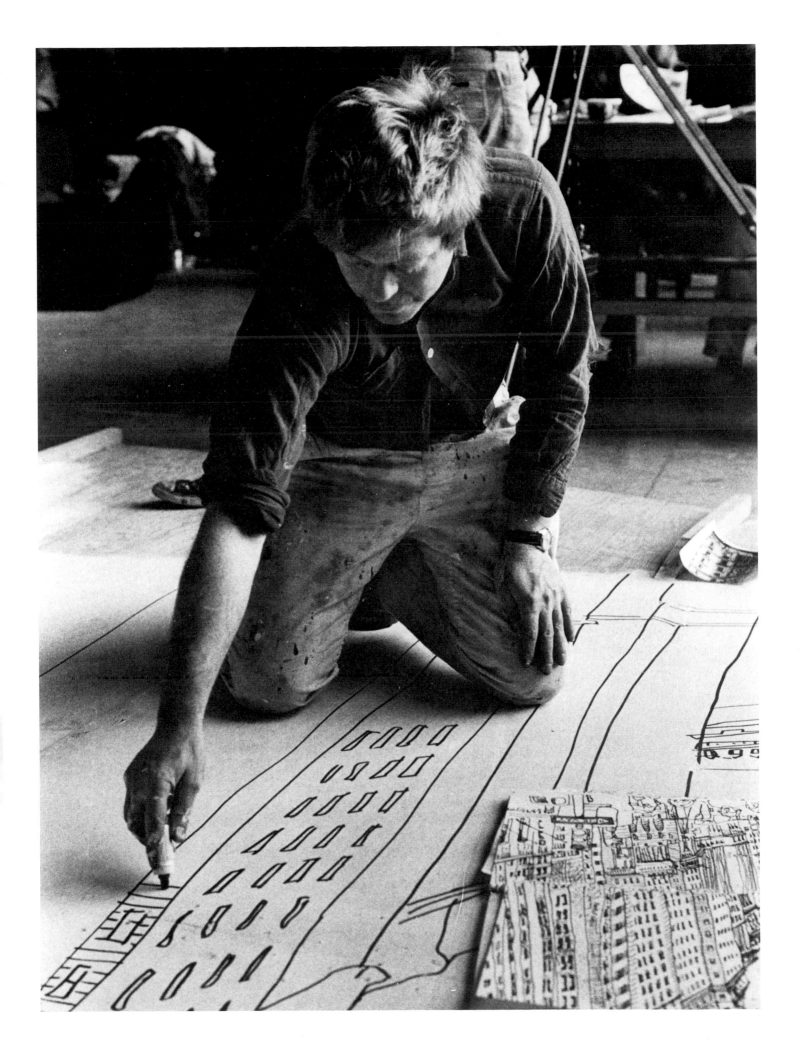

Alice and Alec in Groomsland: A Guided Tour

Perched at the mouth of the East River, the sculpted chrome-yellow curve of the Marine & Aviation's "Dame of the Narrows" passenger ferry (Pl. 1) rocks and rolls on a bed of undulating powder-blue nylon river water, churning toward her ferry slip at the southern tip of Manhattan's Financial District (Pl. 45).

In her wake, a flock of papier-mâché seagulls (Pl. 2) maintains a nutritional vigil over the Dame's palatable trail of garbage-and-diesel cologne. Sightseer-tourists Alice and Alec board the rubber-inlaid wooden deck of the ferry (Pl. 3) with us, their weight causing the plywood rockers of the chassis to rock back and forth, and meander by the incandescently lit multitiered bread-box size plexiglass dioramas. Rapid eye movement is essential in passing a snackbar with a painted-vinyl panoramic view of Ellis Island and the Statue of Liberty, a waiting room with miniature wooden benches and beanbag passengers, and a cargo area with bumper-to-bumper carved-wood passenger vehicles (Pls. 4, 46, 47, 49).

Nooks and crannies tease the ever stimulated eyeballs on this sea-ready cartoon montage of life aboard the Staten Island Ferry. A rat scurries across the engine room, a first mate goggles over a chapter in *Jaws*, two stokehole "Hairy Ape" wipers cut cards in the smokestack under a Dantesque swirl of fire and smoke (Pl. 48). Split in half on matching sides of the bifurcated pilot house is an X-rayed Davy Jones figure with a cannon for a brain and cannonballs for intestines, sitting atop two Manhattan yellow-page phone books and a mysterious treasure chest (Pls. 4, 46).

The icing on this sea-going layer cake is Beelzebub himself, encapsulated in the smokestack, tongue wagging, horns glowing, stoking the fires of Hell, with a background view (acrylic on vinyl) of Gotham's skyline (Pl. 50).

Seemingly unaware of the Ruckus on board, a bearded Toulouse-Lautrec cut-out in short pants grips his lens-heavy 35mm camera, waiting for the perfect Statue of Liberty shot. Emblazoned on his cap—a significant clue to the overall helter-skelter jitterbug of this showboat—is the name "Archie," the chief engineer of the Ruckus crew (Pl. 5).

Ms. Liberty (Pls. 6, 51) obediently zooms into focus, an exotic creature of fiberglass and celastic, her fire-engine-red-enamel platform heels grinding into the ponderous pedestal on Liberty Island. Hips slung in blasé contrapposto, she wearily lifts the torch of the Free World like a cigarette between two fingers. In the crook of her left arm, Ms. Liberty's transparent purse reveals her fliptop Marlboro cigarette habit and makeup preference.

Swiveling our roving voyeurs northward, the unmistakable skyline of Manhattan (Pl. 7), a spray-painted, aerosol-enameled, welded wire mesh scrim, swamps our already dizzy perspective as we disembark from the ferry on a shaky wood and metal drawbridge.

Squinting into the dazzling sunlight reflected off the East River, the glistening metal structure of the Brooklyn Bridge (Pls. 8, 52-54) engulfs our horizon. A lone freighter, smokestacks blazing and deck rigging jutting out at an impish Art Nouveau angle, snakes under the flowing arch of this symphony of steel. Covering a modest area of 902 square feet and reaching a height of 16 feet, the *Ruckus* version salutes the creator and chief engineer, John A. Roebling and his son and daughter-in-law, Washington A. and Emily Roebling, with sculpted metal Cubist busts at the east and west towers of the bridge (Pl. 54). The Roeblings' project, connecting Manhattan and Brooklyn with 6,000 feet of suspension cable, took thirteen years (1870-1883) and $15 million. The *Ruckus* Bridge, welded in an orgy of flesh burns

against a near-catastrophic six-week deadline, is a walk-on affair featuring a whizzing cyclist and weekend Boy Scout troop tramping under the fishnet strands of the suspension cables (Pl. 53).

Threading their way westward along the angular, steeply inclined plywood streets of Wall and Broad, Alec and Alice discover that the Groomsland parody darkens in tone and content. Shadows multiply and the claustrophobic sensation of granite facades and towering monoliths sobers our daffy foray into the 50-foot-long financial district (Pls. 9-15, 55-65). His feet firmly planted on a Con Edison sewer plate, Alec's eyeballs slowly pan skyward to the colossal symbolic eye of God, molded inside a pyramid crowning the Bankers Trust Building (Pl. 57). The burst of all-seeing light around the pyramid completes a triple pun that includes Bankers Trust's pyramid logogram, the backside of the dollar bill's Great Seal, and the outrageous notion that God remains omnipotent over the already mighty buck of Wall Street.

Returning to street level, a peripheral glance north reveals the foot of Nassau Street, the tacky consumer playland for lunch-time Wall Streeters. The image of sputtering franks slowly revolving on automatic grills, oblivious to the frenzied toetapping of impatient customers, causes a brief pause from the tour. Stomachs replenished with sufficient quantities of the preservative BHT, Alec and Alice regain their momentum.

A pencil beam of noonday light (provided by the strategic placement of 25-watt reflector floodlights) bisects Wall and Broad Streets. The Gothic Revival black steeple of Trinity Church leans over at an intimidating angle (Pl. 57). A camel-haired businessman (covered from head to toe in a rich camel weave), with arms swinging, turns a blind corner and is briefly frozen under an arching street lamp by a gust of wind howling along the narrow corridor of Wall Street (Pl. 9).

The Hole-in-the-Wall Newsstand (Pls. 9-10) cramps the sidewalk with a mounting blitz of newspapers, magazines, and lottery tickets. Each cover issue is a meticulous facsimile, clearly dated and priced. Bathed in an eerie yellow light, the life-size newsvendors Paul Bernstein and Jack Schnair (drawn from real-life models) stand forever ready with wire snippers and correct change (Pl. 10).

As we round the corner at Broad Street, the fluted Ionic columns of the New York Stock Exchange Building soar skyward to an ingenious reprise of J. Q. A. Ward's pedimental sculpture, with a central figure of Integrity supported by ten symbolic figures representing Agriculture, Commerce, and Industry (Pl. 55). Unlike the original, first done in marble and later replaced by lead-coated copper sheet metal, the *Ruckus* version honestly flaunts its sophisticated, celastic construction.

Entering the Exchange at 18 Broad Street, our friends scamper to the Visitors Gallery and cluck their tongues in bewilderment at the scene on the trading floor (Pl. 11). Bedlam is king as scores of traders clash in a duel of profit and loss. The fisheye view offers a riotous fashion show of ill-fitting, creased and clammy dress, no plaid too loud, no stripe mute enough to avoid clashing with a hostile sharkskin. Tiring quickly of the seemingly mindless activity on the floor, we backpedal for a breath of fetid air and a closer look at the naked lunch on the steps of Federal Hall.

Willie the Preacher is lambasting the lunch-time crowd under the hulking statue of George Washington (Pls. 12, 59; see also Fig. 12). Willie's mouth is a wide-open cavern, his arm stretching toward heaven, his index finger rigidly extolling the virtues of Jesus the Savior. George stands benignly mute to Willie's folly. His skin-tight breeches appear ready to pop at the seams as he leans forward at the crease of his monster-size boots, as if straining to appear aloof to Willie's siren song. George is painted in flat stagepaint colors, contrasting sharply with Willie's loud acrylic plaids. The recipients of this fire-and-brimstone

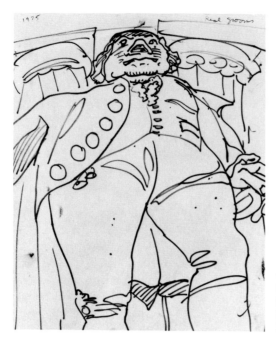

12. Sketch of the statue of George Washington for "Wall Street," 1975. 24 x 18". Photograph by Robert E. Mates, courtesy Marlborough Gallery, New York.

harangue are an ungodly crew of chomping, dozing, and ogling zombies (Pl. 13). Like the statue behind him, Willie is a well-known Wall Street landmark.

A touch of disaster is in order, to break up the pace, to inject some hysteria into the limelight. There's a fire, an explosion, a flood of flying bricks cascading over unwary victims (Pl. 60). Mother Bank got hit, bombed by a mad-dog anarchist. The scene is a dance of death, comical yet devastating. You have to keep your eyes open for this sort of thing in *Ruckus Manhattan.*

Seeking refuge from the crumbling pillars of Mother Bank, we cross lower Broadway by walking up a precipitous wooden ramp and approach the pastor at Trinity Church (Pl. 14). Walking past a shoeshine man and subway station en route to Trinity's cemetery, the sudden unmistakable sight of skeletons freezes our attention. Sure enough, a reclining Robert Fulton, clasping his steamboat, and General Alexander Hamilton, clutching his fatally slow duelling pistol, jar the collective memories of local history (Pl. 15). Above this ghoulish crypt the tranquil landscaped graveyard of Trinity soothes our Ruckus-shocked explorers.

The last stop on the Wall Street sculpt-o-rama is the 3D Chase Manhattan Plaza at Cedar and William Streets (Pls. 61-65). The tree-and-bench-lined oasis is dominated by Jean Dubuffet's *Four Trees* sculpture (whose irregular shapes look quite at home in the *Ruckus* version) and a sunken Isamu Noguchi rock garden (Pl. 64). The Plaza is a crossroads for pedestrian traffic and the black, white, and silver painted vinyl and plywood panels (they were painted at Marlborough Gallery on an overcast spring day) explode in a frenzy of momentum (Pl. 65). The Chase Manhattan tower, like Trinity Church's steeple and George Washington's torso, tilts forward across the creamy white ceiling of Marlborough Gallery. Behind the aluminum-skinned exterior, cutaway slices of office life add another layer to the manic quality of *Ruckus's* insatiable thirst for detail.

Bidding a frenetic farewell to the architecture of Skidmore, Owings, and Merrill, the Ruckus Rickshaw moves on to Cass Gilbert's 1913 cathedral of commerce, the Woolworth Building, across the park from City Hall on lower Broadway (Pls. 16-20, 66-67). The creamy terra-cotta exterior is getting a shampoo from foreman Jeff Kramer (Pl. 17), a Guinness Book of Records holder who survived a leap from the George Washington Bridge. (His family has been intimately involved

with the 7,500 tons of terra-cotta since Frank W. Woolworth financed the structure.) *Ruckus* Woolworth delicately parodies the Old World craftsmanship and "Five & Dime" philosophy of Frank W. A green currency-plated dragon straddles the Gothic pointed arches, finials, and crockets of the tower. This outrageous gothic creature, fully mechanized and waterproofed for outdoor display, executes a slow, creaking waltz of flapping wings, roving head, and masticating jaws. His mechanical innards of springs, cables, and motor are covered with plywood, plexiglass, fiberglass, and foam core. The Woolworth dragon is pock-marked with light-bulb fixtures and waterproofed with rubber gaskets and drainage holes.

Gingerly peeking past the dragon's horny talons we view the green-tinted fluorescent glow of office life. As our eyes career from window to window, a board meeting with a few dozing participants, their feet propped up on the conference table, dissolves into a brief water-cooler romance, as office lovebirds coo and flirt. Keeping in stride with the Midwestern flavor of the Woolworth empire, many of the office workers wear polyester plaid suits and white shoes. One mysterious vignette portrays a pair of phantom hands dragging away an unfortunate office clerk—a reminder of an unsolved murder in early Woolworth history.

At the west façade of the tower we look up and gasp at the vision of Frank W. himself, his gold and brown pin-stripe suited arm supporting a cutout section of his mausoleumlike Gothic tower. Frank is still up there, encased in his throne, mustache combed and eyes blazing like a locomotive (Pl. 18).

One side of the Woolworth Building is occupied by a functioning, life-size revolving door, in which a blue-bonnet lady in plastic raingear and a loud-plaided businessman are consigned to perpetual rotation. Passing through one of the unoccupied quadrants, we enter the lobby where a mosaic ceiling vibrates in blue, green, and gold Byzantine tones. A Teutonic-looking maintenance man buffs the already gleaming inlaid floor (Pl. 19). The entrance arcade and balcony mural are filled with Ruckus bas-relief caricatures of crew members Archie and Connie Peltier, Red, Mimi, and Saskia Grooms, Frank Lloyd and Pierre Levai of the Marlborough Gallery, and (as in the real building) Messrs. Gilbert and Woolworth in top hats and tails.

Around the corner of Church and Chambers Streets, a Greek Revival discount store trumpets its wares in a ghastly display of schlock advertising claims while a sea of candy-colored trinkets flows like lava into the street (Pl. 20). Alec and Alice are tempted to retreat to the growling gargoyles and flying buttresses of the Woolworth Building.

Shocking contrast is the bedrock of *Ruckus Manhattan.* From perpendicular Gothic we are rudely confronted by the spaghetti-western architecture of Minoru Yamasaki's World Trade Center (Pls. 21-31, 68-72). The 30-foot-high "twin" towers, one made of wood, the other of vinyl, interact with a yin-yang play of exaggerated and reverse perspective. They are connected by a steeply inclined vinyl plaza, complete with Broadway Boogie commotion (as on the floor of the Stock Exchange and on Chase Manhattan Plaza) and the *Ruckus* version of Fritz Koenig's 25-ton bronze *Globe* sculpture. Beneath the scurrying feet of buttoned-down plastic commuters, the plaza becomes miraculously transparent, revealing a bird's-eye view of the subterranean PATH (Port Authority Trans-Hudson) terminal (Pl. 22). Banks of motorized escalators spew 150 cut-sheet, pop-up aluminum commuters onto the eternal treadmill of Manhattan madness. A large banner hung over the terminal proclaims: "Give to the United Fund."

Downhill from the sunken PATH terminal, the nine-story Northeast Plaza Building tilts precariously on skinny metal legs (Pl. 69). A mobile trailer filled with java waits for caffeine-starved construction workers.

The roof of the see-through plaza structure presents Grooms's grotesque vision of Miami Beach in Manhattan. A bikini'd sunworshipper reclines on a beach towel with a rolling-dice motif, while another tries to impale her striped beach umbrella on the tar-covered roof (Pl. 23). Armed with blasé indifference, our urban sunbathers ignore the real spectacle: the bright yellow glob of a suicide victim (or is it cocoa butter?) dripping to the edge of the roof. It must have been quite a splash from the 110th story.

In the *Ruckus* mockup, the spindly vertical piers of the Trade Tower become a tangle of stringy vines and, on the other side of the wooden tower, a curtain of hanging tubes that can be brushed aside as we walk through the wall to mount a three-story interior stairway to the observation deck. The stairway is sculpted with escalator-style rubber treads and handrails. On the way to the top, we encounter a crouched CIA agent with tape recorder, bugging unheard conversations. Turning back for a moment we see a riveted vinyl businessman seated in his executive office chair, his secretary glued to her steno pad. Behind a plexiglass diorama, a motorized canvas belt moves an endless procession of feet.

At the top of the stairs, under a protective cumulus cloud (which blocked the deadly rain of flaky asbestos from the unfinished Pine Street ceiling: Pl. 70), we are surrounded by eight plexiglass painted panels—a panoramic global view featuring the North Pole with Santa Claus watching his elves sledding; the South with Nashville and a truckload of moonshine; a snake farm in Florida; and Castro playing basketball in Cuba. Off Bermuda, the Devil's Triangle casts a menacing air with an aquatic parking lot full of sunken ships. Spinning westward we discover Hawaii and a Hollywood film director in riding breeches, boots, and beret. Across the Atlantic, the Eiffel Tower pops into view, and in distant Africa brooding natives thump the hackneyed drums of Ramar of the Jungle.

Descending the stairway, we pass painted vinyl murals of office chicanery and a breathtaking view of Manhattan's skyline. At the base of the wooden Trade Tower is a mylar- and formica-coated, fluorescent-lighted elevator with motorized doors that open and close at seemingly random intervals. Five painted Port Authority commissioners hug the rear wall. At the front of the car, obviously uncomfortable and nervously fondling their canvas-and-foam swords, are two navigators and explorers of Manhattan's rivers, Henry Hudson and Giovanni Verrazano (Pl. 25). As the elevator doors close, the interior light goes dark, and the elevator floor creeps up 11 inches, the compression causing the two valiant foam figures to be squished like accordions—only to be unsquished a few minutes later as the doors reopen. Opposite the elevator is another view of the PATH terminal: a 3D model of the two-story station, with painted corridors vanishing into deep perspective (Pl. 26).

The vinyl Trade Tower, unlike her tapered wooden sister, swells outward toward the top. Passing through a vinyl portal, we are confronted by stuffed, sewn-vinyl figures, a mix of secretaries and executives rushing through the Trade Tower lobby. Exiting through the pointed passageway, we are outside again and take a quick spin around the four-sided tower, painted as a tapestry of life real and imagined, and vibrating with Technicolor intensity. One panel (Pl. 24) features the Blissberg Old Folks Home, with a billboard advertising "another welfare hotel," artists' lofts (the recycled fate of all Manhattan architecture), and a Ramada Inn. A rickety fire escape, crawling ivy, and wash hanging out on the clothesline give the *Ruckus* Tower a funky, disheveled air, light-years away in style from Yamasaki's sterile Trade Center.

Twisting around the sprawling 25-square-foot base of the Trade

Center, the West Side Highway creaks and groans from the constant strain of a Hertz truck, a vacation van, a white city-sanitation truck, a few space bubbles, Noah somebody's ark, a horse-drawn carriage, and various jumbo trailer trucks. A biplane hovers over this bizarre traffic jam (Pls. 27-28, 71-72).

Confused by the Tower of Babel, necks aching from looking up and down and around, Alec and Alice stagger over to their car on Rector Street (Pl. 30). They are confronted by another zigzagging street scene, surrounded by tilting buildings and snarling packs of taxis and delivery trucks. Our pavement-pounding voyeurs take a last look, a subterranean view of life in the Big Sewer (Pl. 31). Couples of green crocodiles with tan bellies and Colgate-bright smiles dance on a river of sewage (untreated by the look of it) to the blasting beat of stereo speakers suspended from dripping sewer pipes. The spinning disc is Elton John's smash hit, "Crocodile Rock."

Rushing to Chinatown, we encounter a crew of Chinese food wizards constructed from fabric, sculpture wire, foam, and hot glue (Pls. 32-33). In the background a large mural on stretched paper conveys the spicy atmosphere of oriental cuisine—a whole fish steaming in a wok, a heaping tureen of rice, and the essential pot of green tea. Decked in white kitchen fatigues, the back-to-back workers clean fish (entrails oozing), prepare the special bok choy, broccoli, and stalks of scallions, their cleavers thwacking away in a Zenish rhythm. A lethal-looking box of salted hog snouts waits for a fast fry.

For dessert, Alice and Alec agree on porno cake slumming in Times Square. The first stop is King Porn's pulsating, walk-in bookstore, entered through plastic curtains promising eighteen new, live, unadulterated amazons and enough dildos to keep Manhattan buzzing through any future brownouts (Pls. 34-35, 73-74). Eyeballs guiltily locked in place, our fearless voyeurs march past the vinyl curtain to encounter a chain-bedecked, black-vinyl-jacketed lover boy, waiting for his very own Marquis de Sade.

The cigar-chomping King Porn is manning the cash register, and one houndstoothed drooler has his substantial nose buried in a slick-tease magazine. Suspended on yellow pegboard, the magazine-and-dildo rack (direct from Denmark) features such favorite titles as "Ear-licker," "Chain Me," "Group Gropes," and "All Come" (Pl. 74). Fisheye security mirrors survey for lustlifters. One particularly lewd customer is endowed with sex-organ facial features (Pl. 73).

Emerging dizzy from the ultraviolet interior of the porn shop, the weak-kneed couple sway past the wall of "Girls Girls Girls" and start seeing double: six people occupy three bodies in a foam-rubber, canvas, and fabric triptych of pimps, cops, and prostitutes (Pl. 37). The pimps' sunglasses reflect the barelegged stride of their girls and the other symbol of their trade, the automobile. The shielded men in blue swing their phallic nightsticks, their stance arched over an equally tumescent fire hydrant. The gold boots, black fishnet stockings, green hot pants, and lavender halters of the hookers, coiffed with a gold wig and black frizzy hair, cause temporary blindness.

Filling a final island of Times Square sin, a peacock-coated pimp with sequined jacket and ring-laden hand alights from his crushed-velour-topped Pimpmobile to check out his chattel—a soaring six-foot-high amazon in red stacked boots, her head framed under a curved street lamp (Pl. 36). In a "Mr. Natural" crouch, the pimp steps onto the curb, braced by his outlandish walking stick. This fabric and foam sculpture is mockingly sensual, from the white-furred continental kit on the rear of Mr. Natural's mobile showcase to the hot red lips of his Master Charge kewpie doll.

From the funk and chutzpah of 42nd Street, the *Ruckus* revelers lurch to another world, a mere eight blocks (or ten *Ruckus* paces)

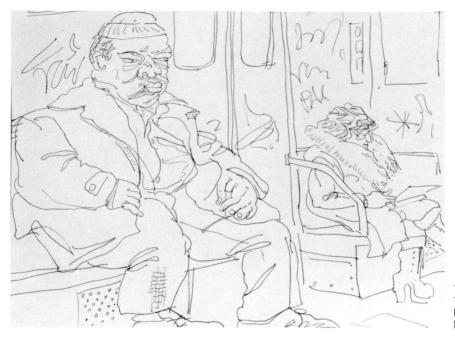

13. Sketch for "Subway," 1976. 18 x 24". Photograph by Robert E. Mates, courtesy Marlborough Gallery, New York.

away at Rockefeller Plaza. The decadence swivels 360 degrees to a pair of giant eight-foot-high Tourists in pastel plaids and chunky cheesecloth, monumental in their plaster stability (Pls. 38, 75-76). Their legs span a vinyl ice-skating rink and rest on the border of azalea hedges. Mrs. Tourist's shoulder bag displays an impressive array of souvenirs. Mr. Tourist's neck is bent forward from the weight of his single-lens reflex camera. His free arm cradles a New York City souvenir plate.

Eyeballing the hem of Mrs.'s polyester shift and Mr.'s windowpane checks, the packed rink of diminutive skaters glide across the ice to a Wurlitzer waltz below the gilded fountain statue of Prometheus, identified by an inscription as the mythical bringer of the hoochie coochie (Pl. 76).

Alice and Alec discover their car has been towed during dessert and dash for a subway station. A quick pan to the token booth reveals three nudes—a *Ruckus* first—queued for takeoff (Pls. 39, 77). The No. 6 Lexington Avenue local roars into the station at an ear-wrenching 100 decibels (Pl. 78). Thudding through the turnstiles (Pl. 79), the hysterical couple ignore the teeming masses, advertisements, flower and tie shops, even the fat girl on a fortune-telling scale (Pl. 40), and barely squeeze past the closing subway doors (Pl. 80). One squished soul is not so fortunate (Pl. 81).

The salmon-colored seats are crammed with a hybrid assortment of larger-than-life plaster and cheeseclothed proletarians (Pls. 41-44, 80-82). An advertisement screams: "Attention Birdbrains, the computer field is wide open to anybody with half a brain. Call 000-0000."

Each jolt of the 37-foot-long subway car (planted on a bed of heavy-duty car springs) pushes you closer to the drunk snoozing on the lap of a bug-eyed, birdlike creature with knees cringing in harmony (Pl. 42). Another bounce and you're jostled to another bench, occupied by a panting pooch in tartar-plaid carrying case (Pl. 82). "Lay away something for these grim days ahead" warns a black-humored jingle. The plot thickens as a little red-snowsuited Goldilocks howls in horror at the thyroid-swollen monster who unabashedly strokes her head. Mom (her feet dangling) looks on in wornout wonder (Pl. 43).

Exiting at the 14th Street station (Pl. 44), Alice and Alec trudge on in search of their impounded car. Passing the mosaic tiles of the subway platform, a disgruntled urban cowboy kicks a frigid vending machine in a paroxysm of frustration (Pl. 83).

Alice and Alec vanish as the detail of a bootblack and racing form

capture our attention. The last exit, a final golden yellow warning, "avoid arrest—pay your fare," snares a culprit in the act (Pl. 84).

Ruckus Resurrection

Resting on a secluded knoll behind the surreal façade of the San Francisco DeYoung Art Museum lies an architectural amnesia victim, the short-term fantasy of publishing tycoon William Randolph Hearst. Scattered about the lush garden of Golden Gate Park are the remains of a Spanish monastery purchased by Hearst on a globe-trotting whim and dismantled and crated for passage to California. Each piece was coded in whitewash, and the cortege of crates wound up in temporary storage in a warehouse in New York City. A freak fire beckoned the fire department, and the resulting torrents of high-pressure water washed away the whitewash markings along with Hearst's dream to resurrect the sanctuary. And so it rests, a marvelous makeshift bench for a picnic or fireplace, unidentified and forgotten.

Red Grooms and his Ruckus Construction Crew use indelible, waterproof magic markers in their inventory work. All of the large environmental pieces are in some form of storage, waiting for a commission, a deal to come out of the closet. *Ruckus Manhattan* has temporarily run out of steam. The crew, too. Like a giant erector set for a sophisticated third-generation computer, *Ruckus* is catalogued and indexed, cross-filed and sketched and documented for future installations. The architectural jigsaw puzzle will pop back to life another time, another place. *Ruckus* might wind up in a shopping center in Beverly Hills or a snake farm in Florida. If only justice would triumph, the massive minimetropolis will resurface on the streets of Manhattan, behind a richly deserved, highly ornamental glass façade, so all the speeding passersby can steal a look at the indefatigable *Ruckus*.

Ruckus Construction Co.

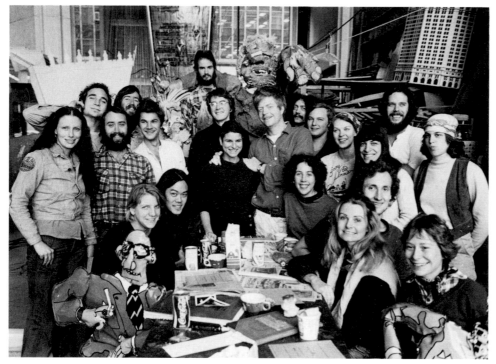

14. The Ruckus Construction Co. relaxing at the No Gas Cafe, 88 Pine Street. *Seated* (*left to right*): Vinyl businessman from the World Trade Center, Nancy Tyndall, John Arakawa, Jody Elbaum, Peter Julian, Robin McDaniel, and Carol Mazurek. *Standing* (*left to right*): Janet Gilmore-Bryan, Mark Samuels, Dan Kingerly, Fred Klein, David Saunders, Archie Peltier (*top*), Chip Duyck, Mimi Gross Grooms, Red Grooms, Kent Hines, Andrew Ginzel, Connie Peltier, Carol Steen, Bob Mack, and Jill Sternberg. Photograph © 1976 by Fred W. McDarrah, New York.

Director: Red Grooms

Director's Director: Mimi Gross Grooms

Chief Engineer: Archie Peltier

Carpentry: Fred Klein (Head Carpenter), Kent Hines, Dan Kingerly, Archie Peltier, Charlie Powell, John Arakawa, Andrew Ginzel, Chip Duyck, Peter Julian, Red Grooms, Jim Brennan.

Drawing: Red Grooms, Mimi Grooms.

Electricity: Andrew Ginzel, Kent Hines, Charlie Powell.

Fabric Construction: Jody Elbaum, Connie Peltier, Jill Sternberg, Letha Botts.

Fastenings: Connie Peltier, Jody Elbaum, Jill Sternberg, Kent Hines, Chip Duyck.

Filming of the work in progress: Peter Hutton, Rudy Burckhardt, Charlie Ahearn, John Arakawa, Jacob Burckhardt, Red Grooms.

Mechanics: Kent Hines, Andrew Ginzel, Archie Peltier, John Arakawa.

No Gas Cafe: Connie Peltier, Jody Elbaum.

Painting: Mimi Grooms, Robin McDaniel, Carol Mazurek, Jill Sternberg, Mark Samuels, Chip Duyck, Janet Gilmore-Bryan, Fred Klein, Red Grooms, Nancy Tyndall, Jody Elbaum, John Arakawa, David Saunders Rolla Herman, Peter Julian, Ollie Alpert, Connie Peltier, Archie Peltier, Bob MacAleavy, Barbara St. James.

Research Photography: Fred Klein.

Plaster: Peter Julian, Robin McDaniel, Dan Freeman, Carol Mazurek, Mimi Grooms, Red Grooms.

Plastic Construction:

Celastic—John Arakawa, Kent Hines, Rolla Herman, Chip Duyck, Jody Elbaum, Nancy Tyndall, Mimi Grooms, Connie Peltier, Peter Julian.
Fiberglass—Rolla Herman, Connie Peltier, Mimi Grooms, Chip Duyck, Nancy Tyndall.
Formica—Fred Klein, Dan Kingerly.
Plexiglass—Charlie Powell, John Arakawa, Kent Hines, Andrew Ginzel, Peter Julian.
Vinyl—Jill Sternberg, Connie Peltier, Jody Elbaum, Chip Duyck, Kent Hines.

Welding: Archie Peltier, David Saunders, Carol Steen, Charlie Powell, Tim McClellen, Andrew Ginzel, Bob Mack.

Wire Screen: Connie Peltier, Carol Steen, Bob Mack.

Red Grooms

Selected Solo Exhibitions

1958 Sun Gallery, Provincetown

1958–59 City Gallery, New York

1960 Reuben Gallery, New York

1962 Nashville Artists' Guild

1963 Tibor de Nagy Gallery, New York

1965 Tibor de Nagy Gallery, New York

1966 Tibor de Nagy Gallery, New York

1967 Tibor de Nagy Gallery, New York
 Allan Frumkin Gallery, Chicago

1969 Tibor de Nagy Gallery, New York

1970 Tibor de Nagy Gallery, New York

1971 John Bernard Myers Gallery, New York
 Institute of Contemporary Art, Boston
 Rented store, Cambridge
 Harry N. Abrams Original Editions Gallery,
 New York

1972 John Bernard Myers Gallery, New York
 Allan Frumkin Gallery, Chicago
 Fendrick Gallery, Washington, D.C.
 Graphics 1 and Graphics 2, Boston
 Cheekwood Museum of Art, Nashville

1973 John Bernard Myers Gallery, New York

1973–74 *Traveling retrospective exhibition:* Rutgers
 University Gallery of Art, New Brunswick;
 New York Cultural Center; Museo de Arte
 Contemporaneo, Caracas

1974 John Bernard Myers Gallery, New York

1975 Brooke Alexander Gallery, New York

1975–76 *Ruckus Manhattan:* 88 Pine Street, New York;
 Marlborough Gallery, New York

Selected Group Exhibitions

1960 *New Media–New Forms* I: Martha Jackson
 Gallery, New York

1964 *Annual American Exhibition:* Art Institute of
 Chicago

1965 *The American Realism:* Worcester Art Museum

1966 *Still Life:* Museum of Modern Art, New York

1968 *Esposizione Biennale Internazionale d'Arte:*
 Venice

1968–69 *Patriotic Images in American Art:* American
 Federation of Arts, New York

1970 *Happening and Fluxus:* Württembergischen
 Kunstverein, Stuttgart; Stedelijk Museum,
 Amsterdam; Der Neuen Gesellschaft für
 Bildende Kunst, Berlin

1970–71 *Figures–Environments:* Walker Art Center (at
 Dayton's Department Store), Minneapolis;
 Cincinnati Art Museum; Dallas Museum of Art

1972 *Ten Independent Artists:* Solomon R.
 Guggenheim Museum, New York

1973 *Extraordinary Realities:* Whitney Museum of
 American Art, New York

1974–75 *Poets of the Cities, New York and
 San Francisco, 1950–1965:* Dallas Museum
 of Fine Arts and Southern Methodist
 University, Dallas; San Francisco Museum
 of Art; Wadsworth Atheneum, Hartford

1976 *Symbols of Peace: William Penn's Treaty with
 the Indians:* Pennsylvania Academy of Art,
 Philadelphia

1976–77 *The Great American Rodeo:* Fort Worth Art
 Museum; Colorado Springs Fine Arts Center;
 Witte Memorial Museum, San Antonio, Texas

Live Performances

1958 *Play Called Fire*
 Sun Gallery, Provincetown

1959 *The Walking Man*
 Sun Gallery, Provincetown

1959 *The Burning Building*
 Delancey Street Museum, New York

1960 *The Magic Train Ride*
 Reuben Gallery, New York

1968 *Berkeley Eruption*
 University of California, Berkeley

1972 *Hippodrome Hardware*
 Ruckus Studio, New York

Selected Films

1961 *The Unwelcome Guests*

1962 *Shoot the Moon*

1966 *Fat Feet*

1969–70 *Tappy Toes*

1972–73 *Hippodrome Hardware*

1972–73 *The Conquest of Libya by Italia, 1913–1912*

1975–76 *Ruckus Manhattan*

Future Releases: *Ruckus Rodeo, Madames et
Messieurs, L'Exposition*

Selected Bibliography

General

Philip Dennis Cate, *The Ruckus World of Red Grooms*, Exhibition Catalogue, Rutgers University Art Gallery (Elizabeth, N.J.: Berkowitz Press, 1973).

Rose DeNeve, "Red Grooms, The Artist as Animator," *Print Magazine*, September–October 1970, p. 59.

Forth Worth Art Museum, *The Great American Rodeo*, Exhibition Catalogue (Forth Worth: Texas Christian University Press, 1976).

Grace Glueck, "Odd Man Out, The Ruckus Kid," *Art News*, January 1973, p. 23.

Jill Johnston, "Happenings, New York Scene," *Encore*, September–October 1962.

Allan Kaprow, *Assemblage, Environments & Happenings* (New York: Abrams, 1966).

Michael Kirby, *Happenings: An Illustrated Anthology* (New York: Dutton, 1966).

Museo de Arte Contemporaneo, Caracas, *Red Grooms*, Exhibition Catalogue, April 1974.

Ruckus Manhattan: Reviews of the Pine Street Installation

Grace Glueck, *New York Times*, May 27, 1975, p. 31.

Arthur Lasky, *World Trade Community News*, September 2, 1975, p. 6.

Barbara Zucker, *Village Voice*, November 24, 1975.

Judd Tully, *Soho Weekly News*, November 27, 1975, p. 19.

Jean Bergantini Grillo, *New York Daily News*, December 14, 1975, Section 3, p. 1.

Ada Louise Huxtable, *New York Times*, December 21, 1975, Section II, p. 1.

Emily Genauer, *New York Post*, December 27, 1975, p. 13.

Robert Hughes, *Time*, January 19, 1976, p. 72.

Julie Pursell, *Nashville Banner*, January 23, 1976, p. 37.

Ruckus Manhattan: Reviews of the Marlborough Gallery Installation

Michael Andre, *Art News*, April 1976, p. 119.

Hilton Kramer, *New York Times*, May 7, 1976, p. C-12.

Amei Wallach, *Newsday*, May 9, 1976, Part II, pp. 4–5.

Emily Genauer, *Newsday*, May 10, 1976.

David Bourdon, *Village Voice*, May 24, 1976, p. 101.

New Yorker, May 31, 1976, p. 29.

Manuela Hoelterhoff, *Wall Street Journal*, June 2, 1976, p. 1.

Hedy O'Beil, *Eastside Courier*, June 3, 1976, p. 7.

Tom Buckley, *New York Times*, June 7, 1976, p. 57.

Screw, June 7, 1976, p. 14.

J. Nebraska Gifford and M. B. Shestack, *Cue*, June 12, 1976, p. 8.

Cultural Information Service, June 1976, p. 11.

Grace Glueck, *New York Times*, June 13, 1976, Section 2, p. 1.

Jerry Tallmer, *New York Post*, June 19, 1976, p. 36.

Diana Loercher, *Christian Science Monitor*, June 28, 1976, p. 23.

Thomas B. Hess, *New York Magazine*, June 28, 1976, p. 76.

Art & Man, VI:6 (1976), p. 8.

Sherry Baker, *Atlanta Gazette*, July 7, 1976.

Peggy O. Kirkpatrick, *Nashville Banner*, July 7, 1976, p. 56.

Barbara Rose, *Vogue*, July 19, 1976, p. 54.

Richard Lorber, *Arts Magazine*, September 1976, p. 30.

List of Plates

Wall Street 11 x 26 x 51'

12. Willie the Preacher exhorting the Wall Street community from the base of the statue of George Washington on the steps of Federal Hall (P).
13. Lunch-time revelers on the steps of Federal Hall.
14. The pastor of Trinity at the church door, and a bootblack at the subway entrance on Broadway (P).
15. Trinity Church and its graveyard, including the skeletons of two inhabitants: Alexander Hamilton and Robert Fulton.

59. Willie the Preacher and George Washington.
60. Fire on Wall Street: Mother Bank succumbs to anarchist bomb.
61. Chase Manhattan Plaza: panoramic view featuring Noguchi rock garden and Dubuffet's *Four Trees* sculpture, all in pure black-and-white.
62. Chase Manhattan Plaza in real life (Photograph by Gayle Gleason).
63. Chase Manhattan Plaza: detail of *Four Trees*.
64. Chase Manhattan Plaza with office tower stretching across gallery ceiling.
65. Chase Manhattan Plaza: detail of lunch-time strollers.

Woolworth Building 17 x 14 x 15'

16. Overall view (P).
17. Dynastic maintenance foreman Jeff Kramer gives tower terra-cotta a shampoo.
18. Revolving door, and F. W. Woolworth sitting in the tower (P).
19. Interior with mosaics and maintenance man (P).
20. Chambers Street, with Greek Revival discount store, at the rear of the Woolworth Building.

66. Woolworth Building in real life (Photograph by Gayle Gleason).
67. *Ruckus* Woolworth, overall view with umbrella-toting tourist(Photograph by Richard L. Plant).

World Trade Center 27 x 25 x 25'

21. Overall view with plaza.
22. Escalators of PATH station viewed through transparent section of plaza.
23. Northeast Plaza Building rooftop, with sunbathers and suicide victim.
24. Detail of vinyl tower, featuring Blissberg's Old Folks Home (P).
25. Wooden tower, interior: Milar-coated mechanized elevator with explorers Hudson and Verrazano (P).
26. Wooden tower, interior: two-level PATH station in meticulous 3D.
27. Overall view with West Side Highway (P).
28. West Side Highway, with Hertz truck, recreational vehicle, biplane, and joggers.
29. Neolithic Hard-Hat intersected by PATH trains at base of West Side Highway (P).
30. Rector Street at base of World Trade Center towers.
31. Rector Street and subterranean Crocodile Rock (P).

68. World Trade Center in real life (Photograph by Gayle Gleason).
69. Northeast Plaza Building.
70. Overall view with Rector Street and West Side Highway.
71. West Side Highway.
72. City sanitation truck in traffic jam under the West Side Highway.

Chinese Cooks 6 x 4 x 10'

32. Salted hog snouts, fish head, Kung Fu shoes, and crab with chopsticks.
33. Wok mural, cleaver, fish entrails, and velvet spectacles.

Forty-Second Street

34. Porno Bookstore, 9 x 17', exterior.
35. Porno Bookstore, interior: the Houndstooth Peeper, King Porn at the cash register, and pegboard magazine display.
36. Street Light, 10 x 8 x 11', featuring pimpmobile, pimp, and street walker.
37. Girls Girls Girls, 9 x 16'.

73. Porno Bookstore: detail of pricknose sleeze patron.
74. Porno Bookstore: dildo display case direct from Denmark.

Tourists 8 x 8 x 10'

38. Towering Texans trample the azaleas at Rockefeller Center.

75. Side View.
76. Diminutive skaters cast random shadows on the ice.

Subway 9' x 18'7" x 37'2"

39. Token Booth with nude commuters.
40. Subway station mural, with flower shop, Tie City, fortune scale, and tin-cup man.
41. Interior, overall view.
42. A dozing drunk salivates on Miss Prim's lap. Note graffiti and advertisements.
43. Shopping-bag lady with umbrella, mother, little red riding hood, and thyroid monster.
44. Subway car and 14th Street station.

77. Token Booth with nude trio.
78. Front of screeching Lexington Avenue local with terrified port-hole gapers.
79. Turnstiles and entrance to subway.
80. Local youth, doors closing on commuters, and advertisement: "9 out of 10 Ameicans are crazzy. Give to Mental Health."
81. Passenger strangled in subway doors.
82. Mother & child, dog fancier with poodle in plaid carrying case, and blissful sleeper.
83. Platform at 14th Street station, with country music ad and frustrated vending-machine customer.
84. Last Exit to Broadway.

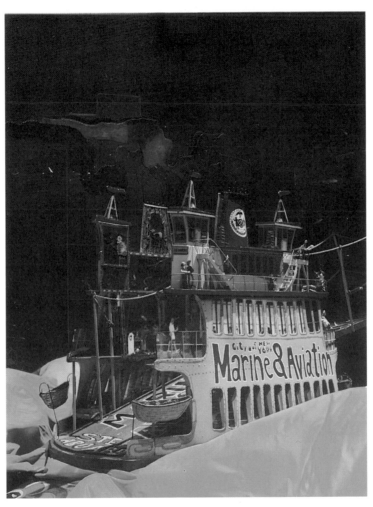

1

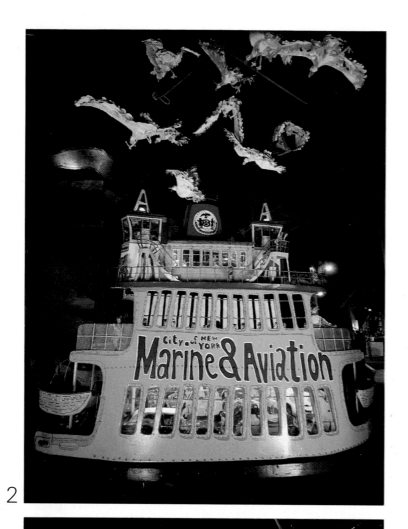

2

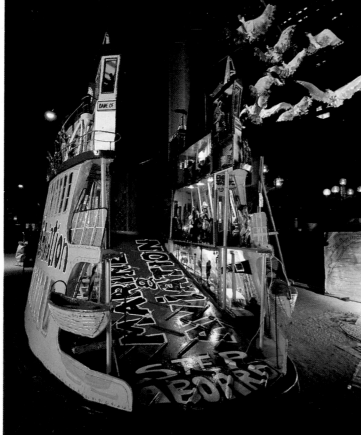

3

4

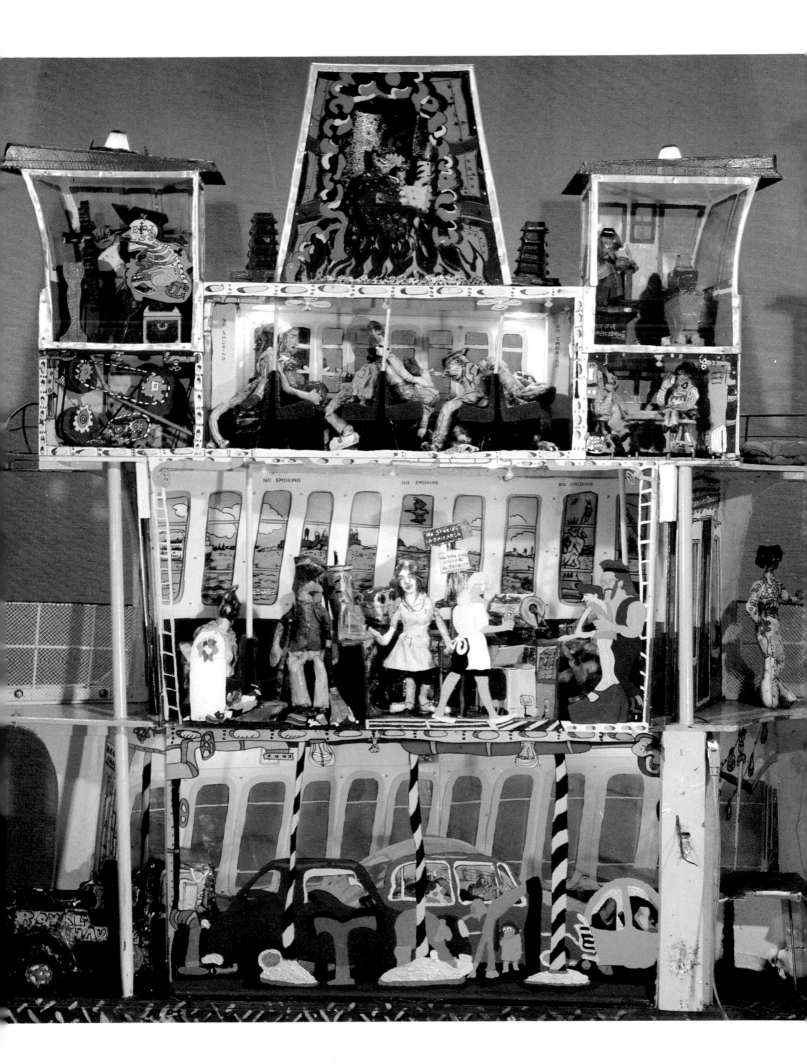

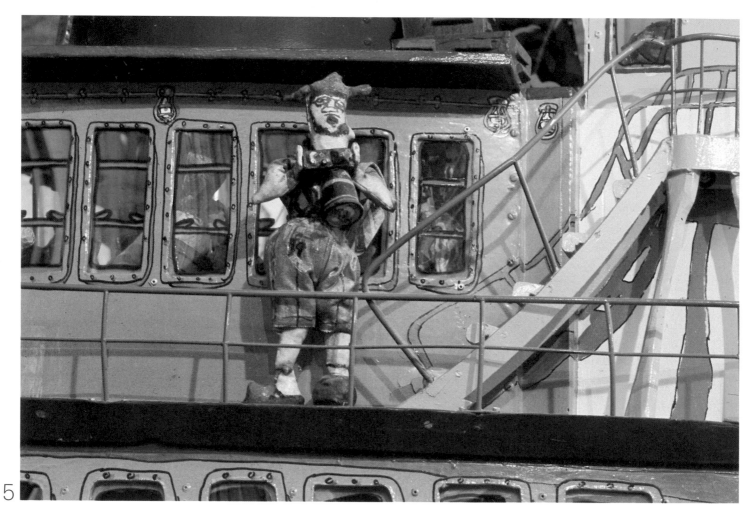

5

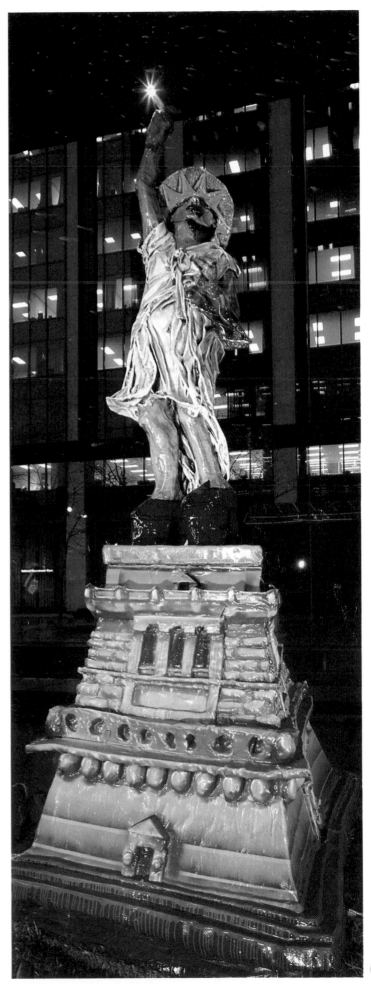

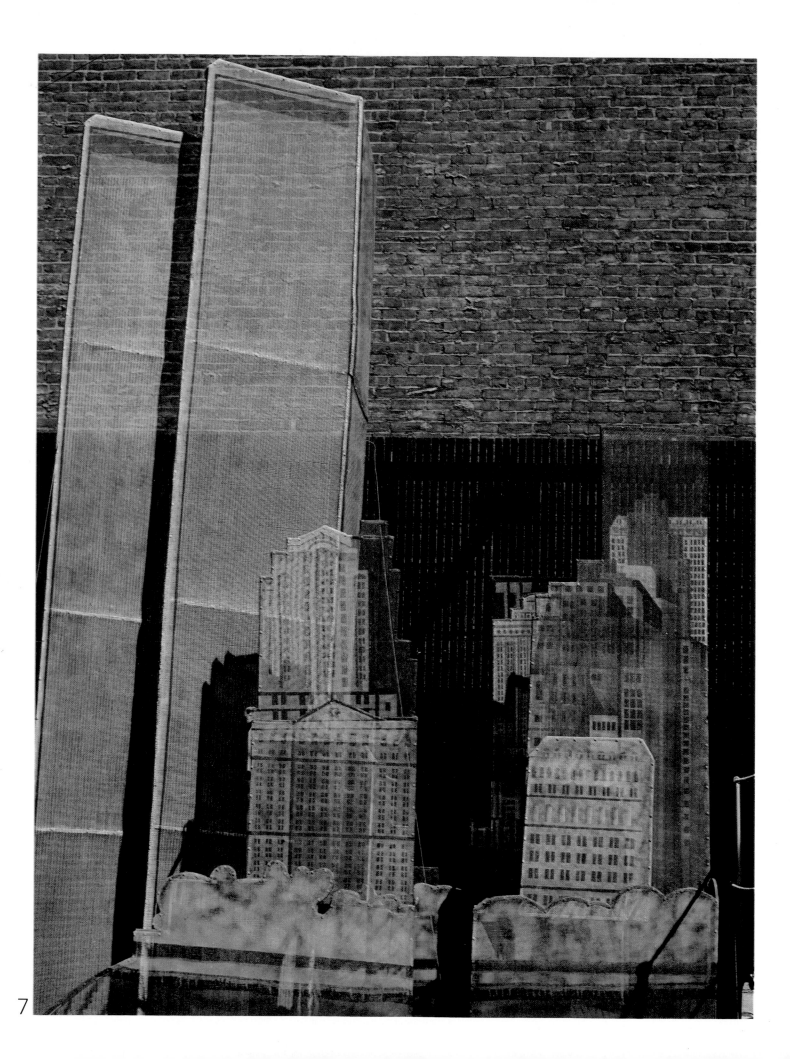

7

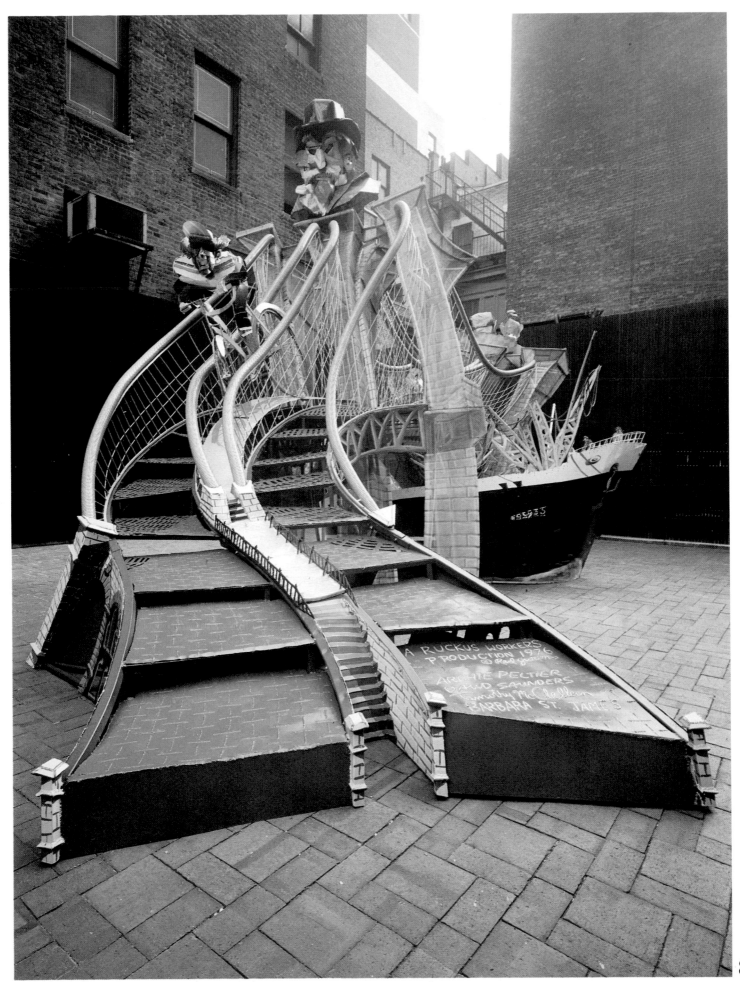

8

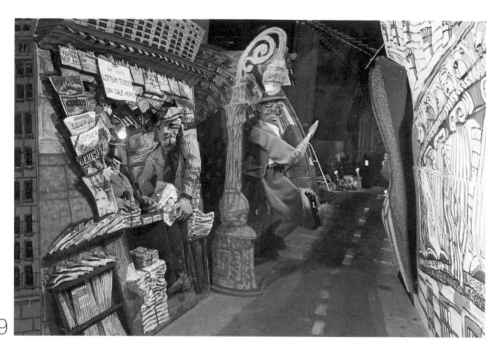

9

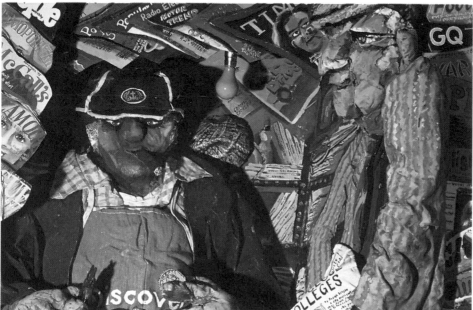

10

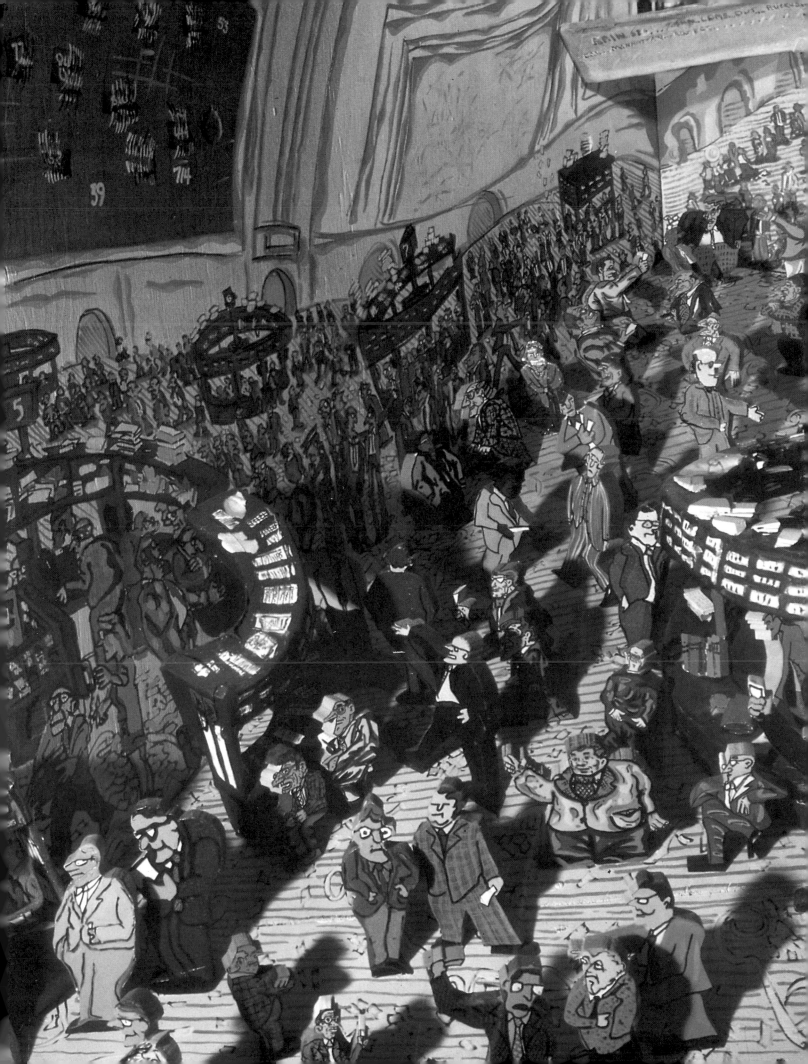

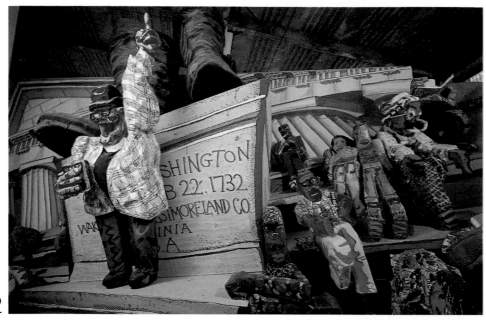

12

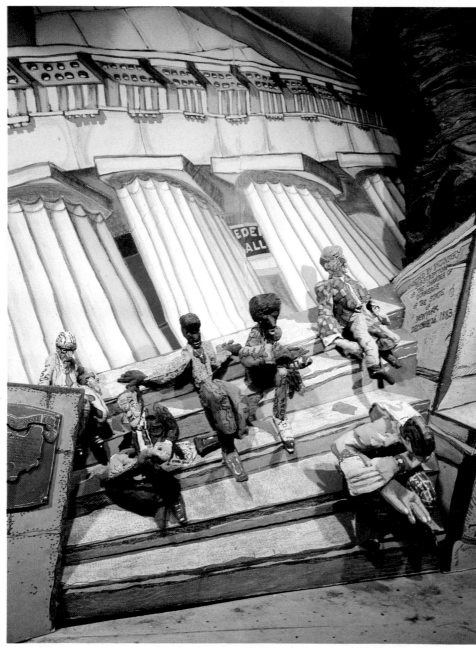

13

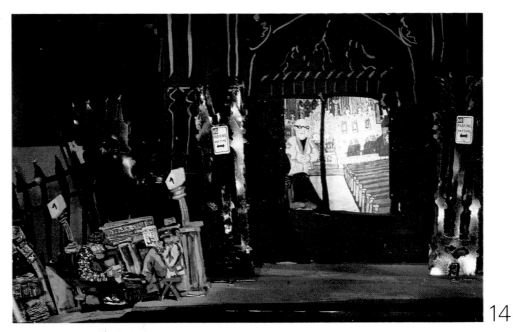

14

15

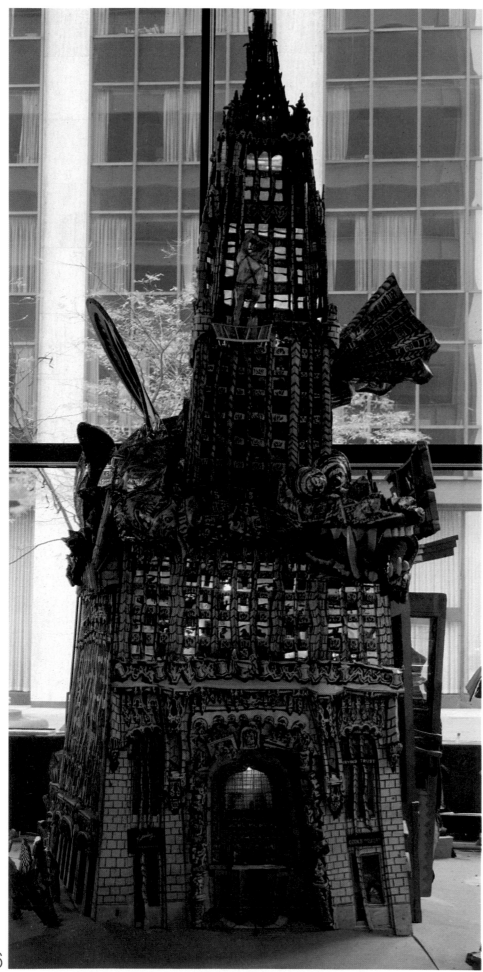

16

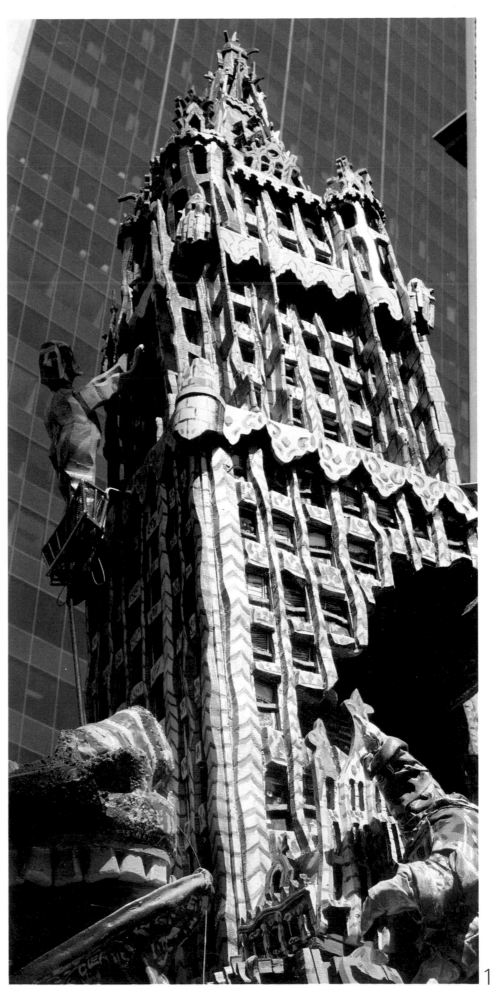

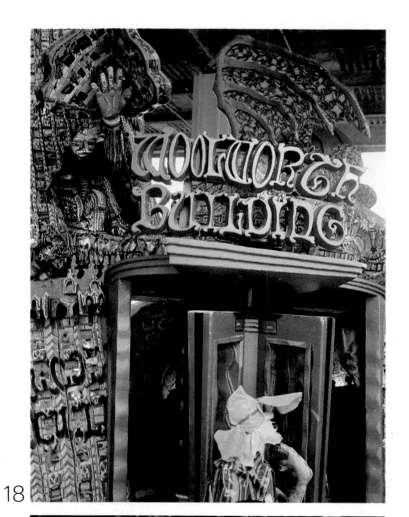

18

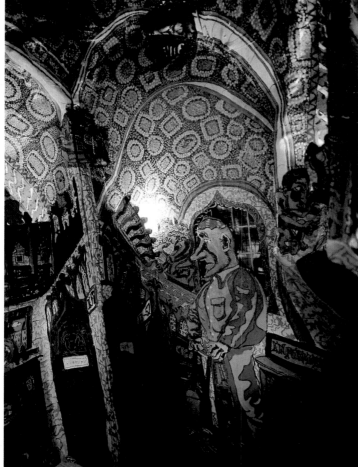

19

20

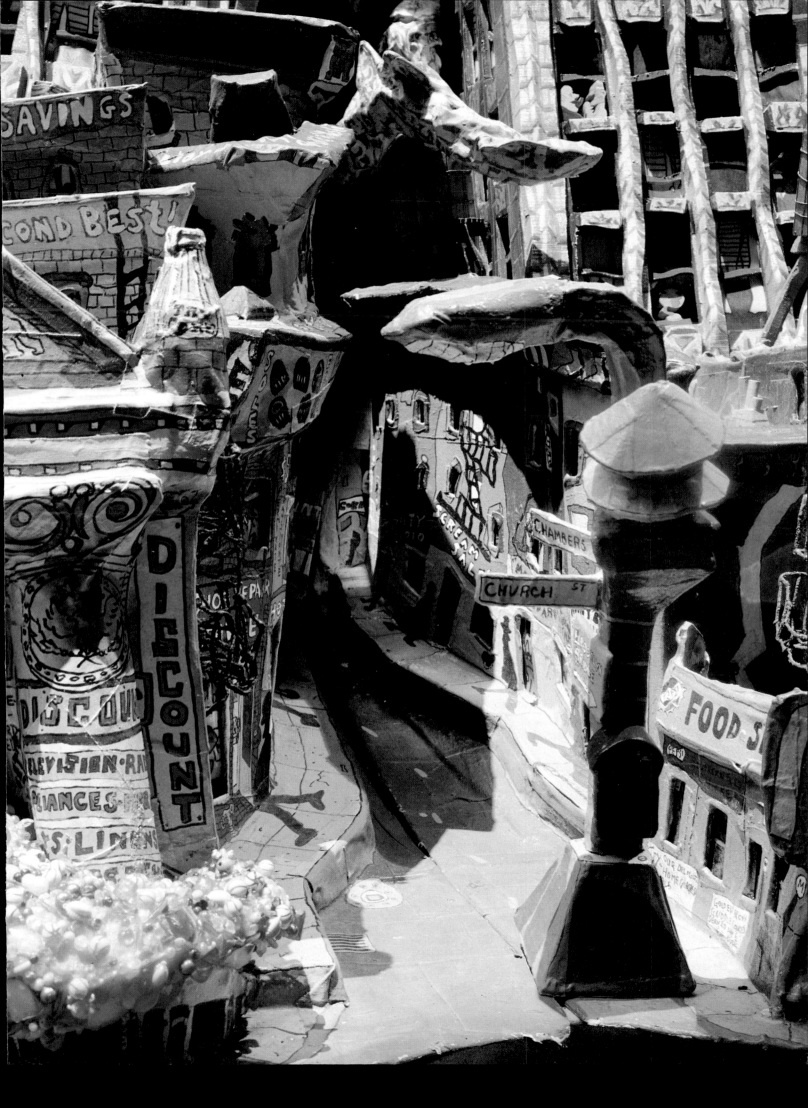

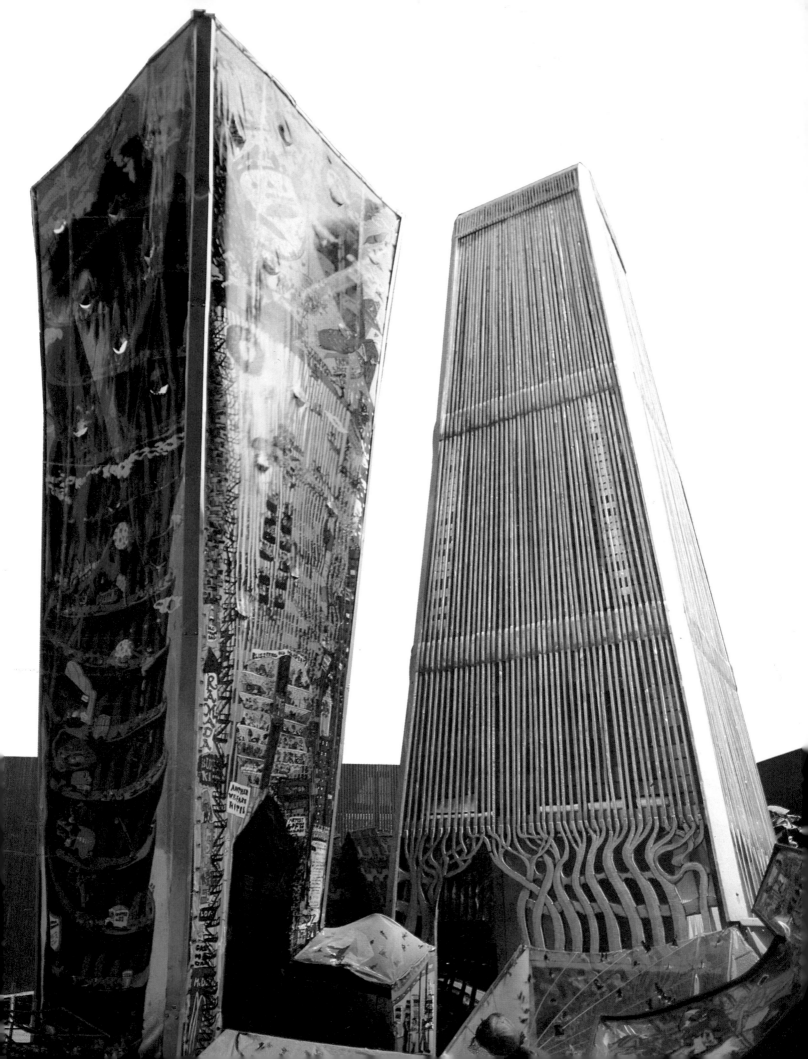

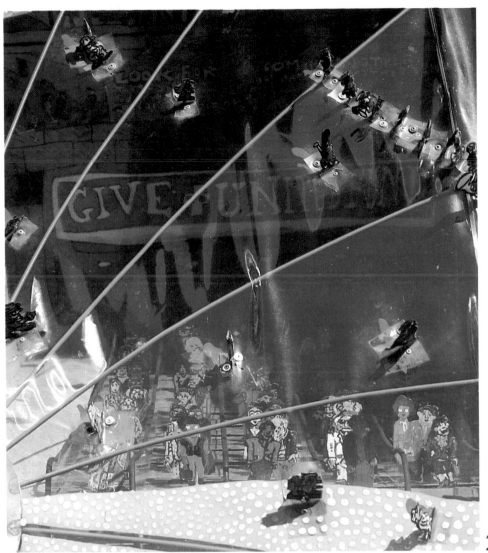

22

21

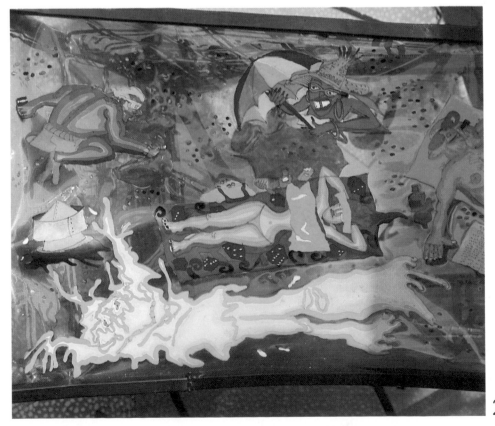

23

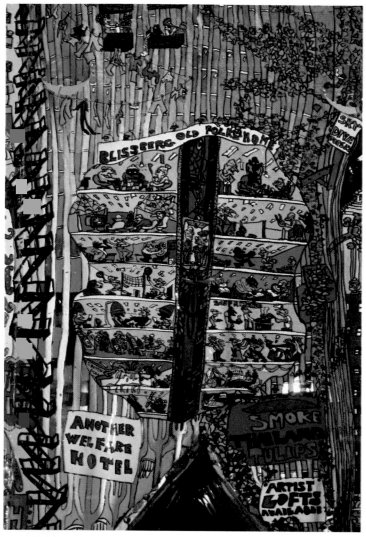

24

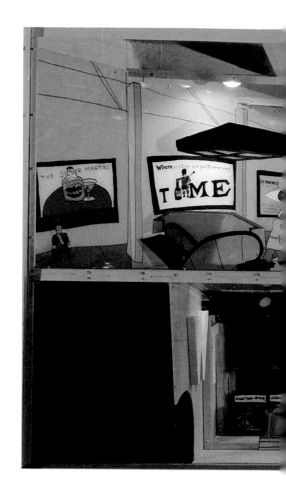

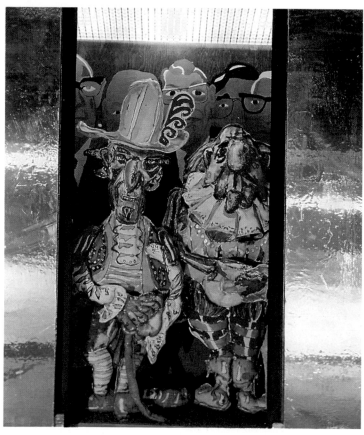

25

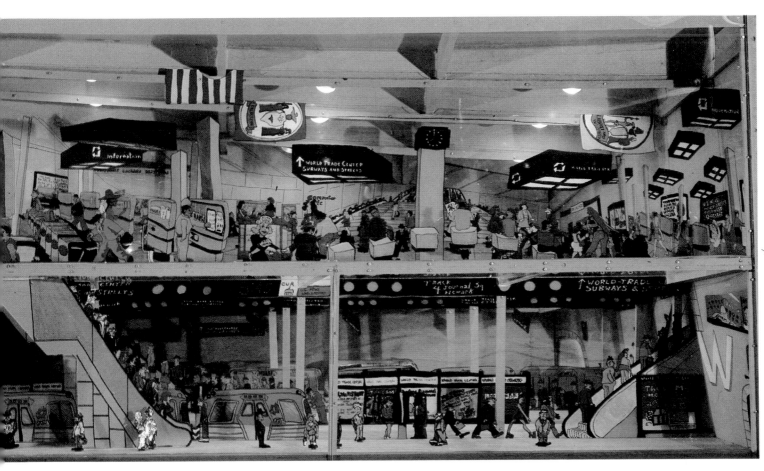

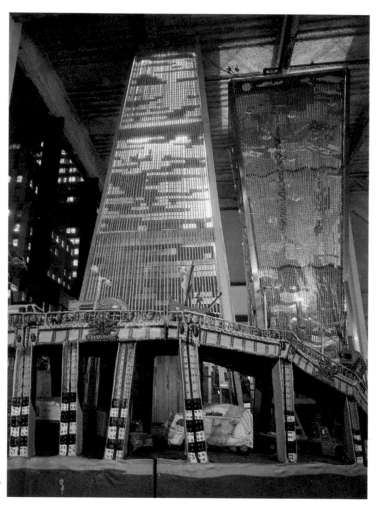

27

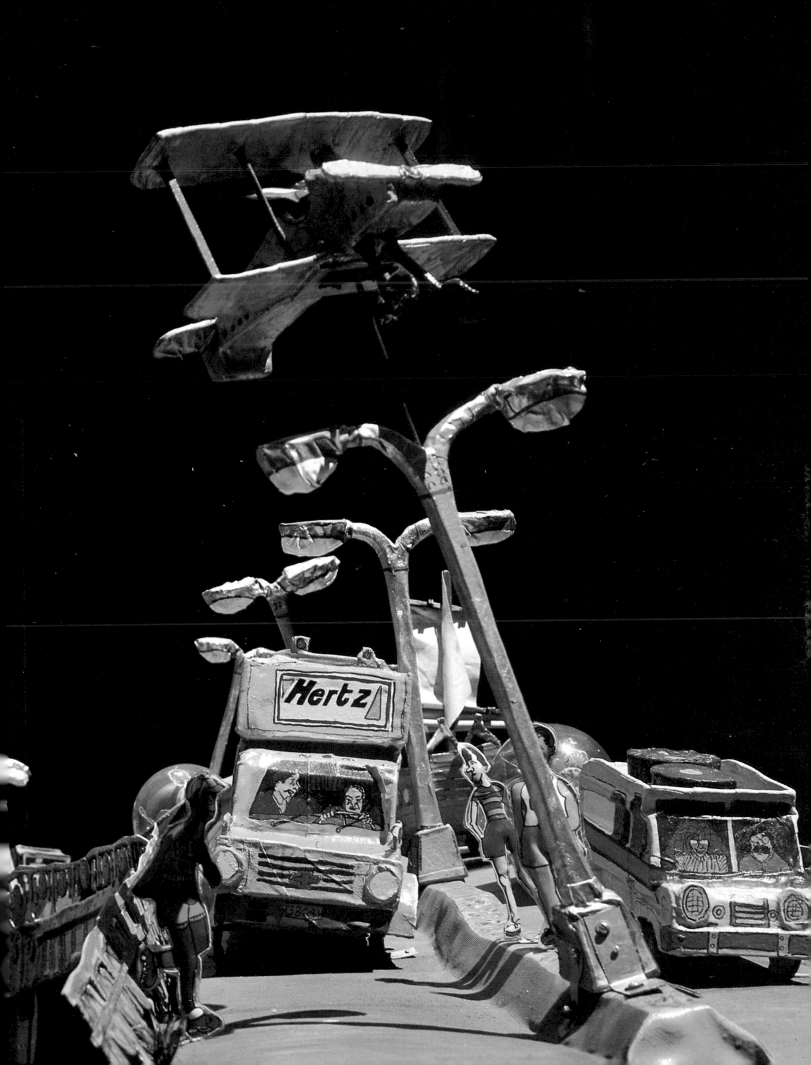

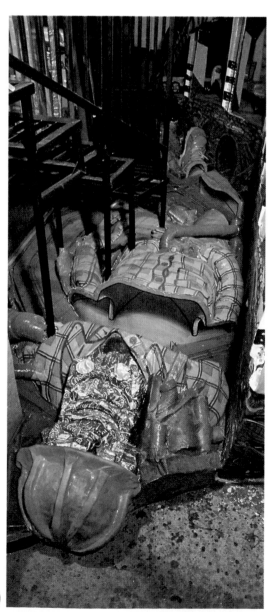

29

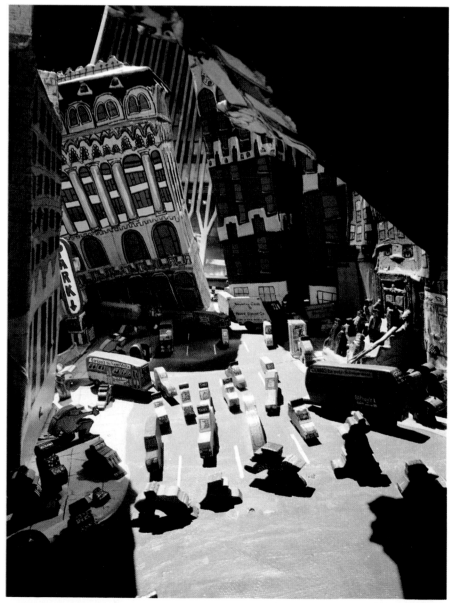

30

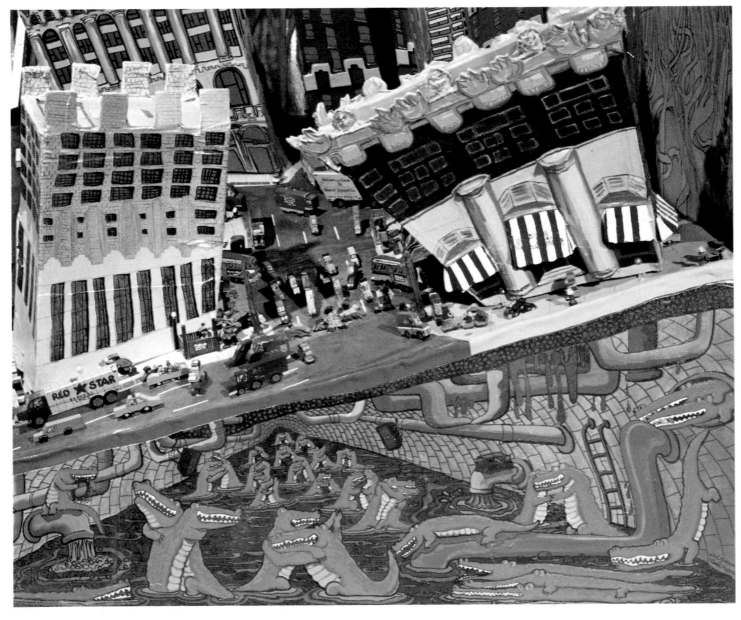

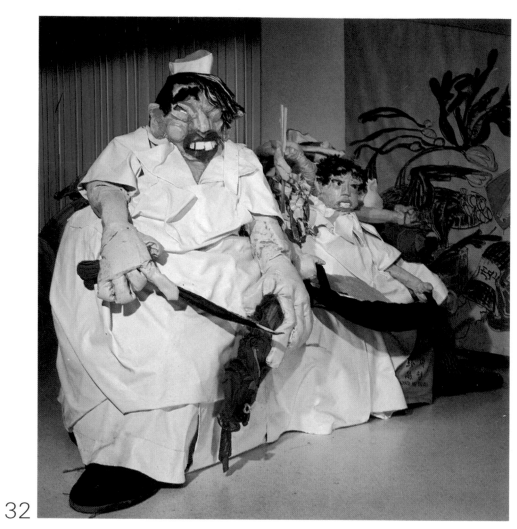

32

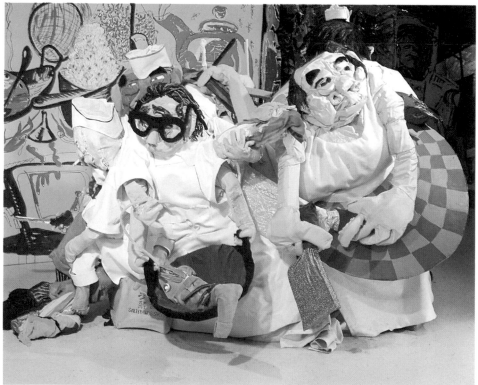

33

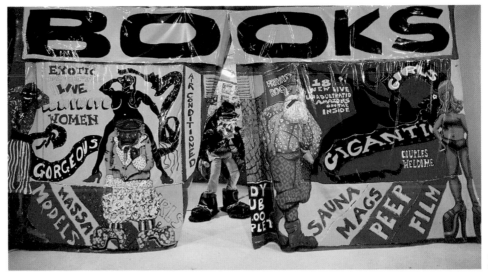

34

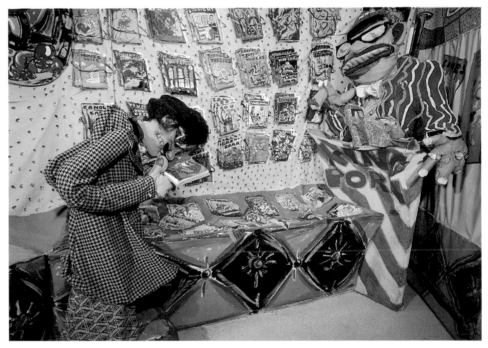

35

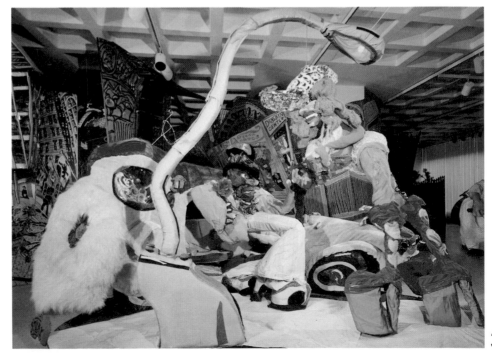

36

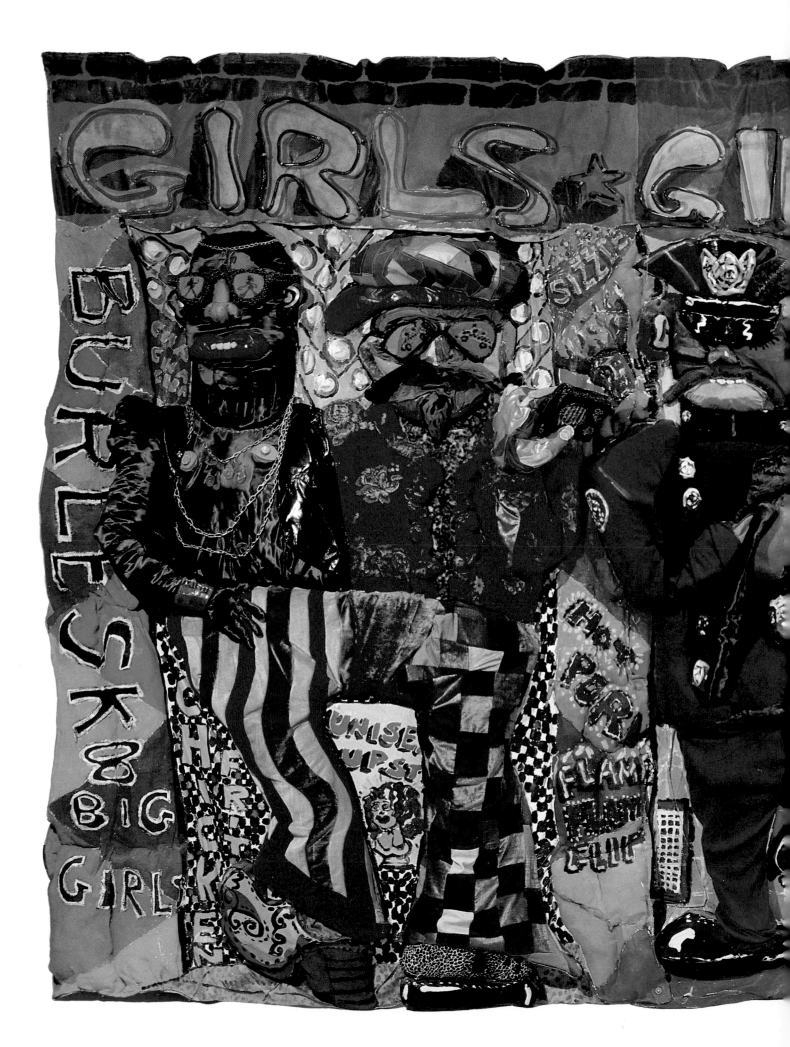

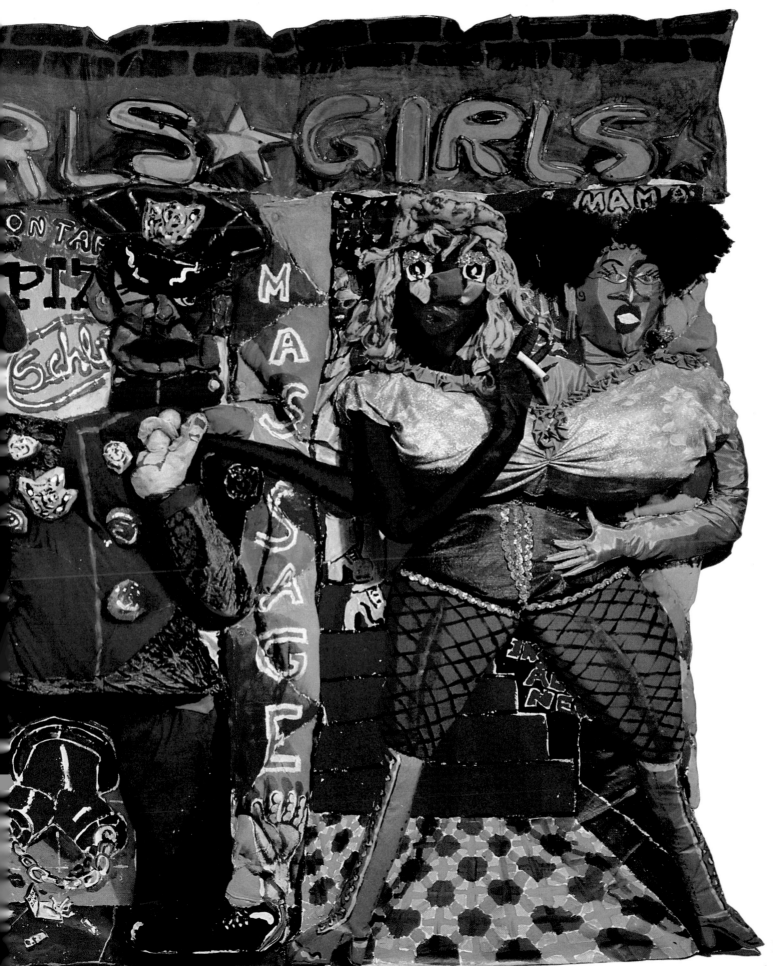

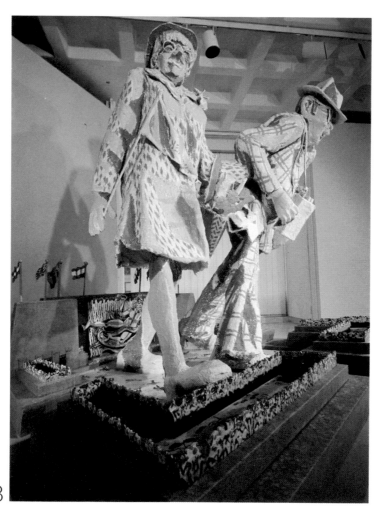

38

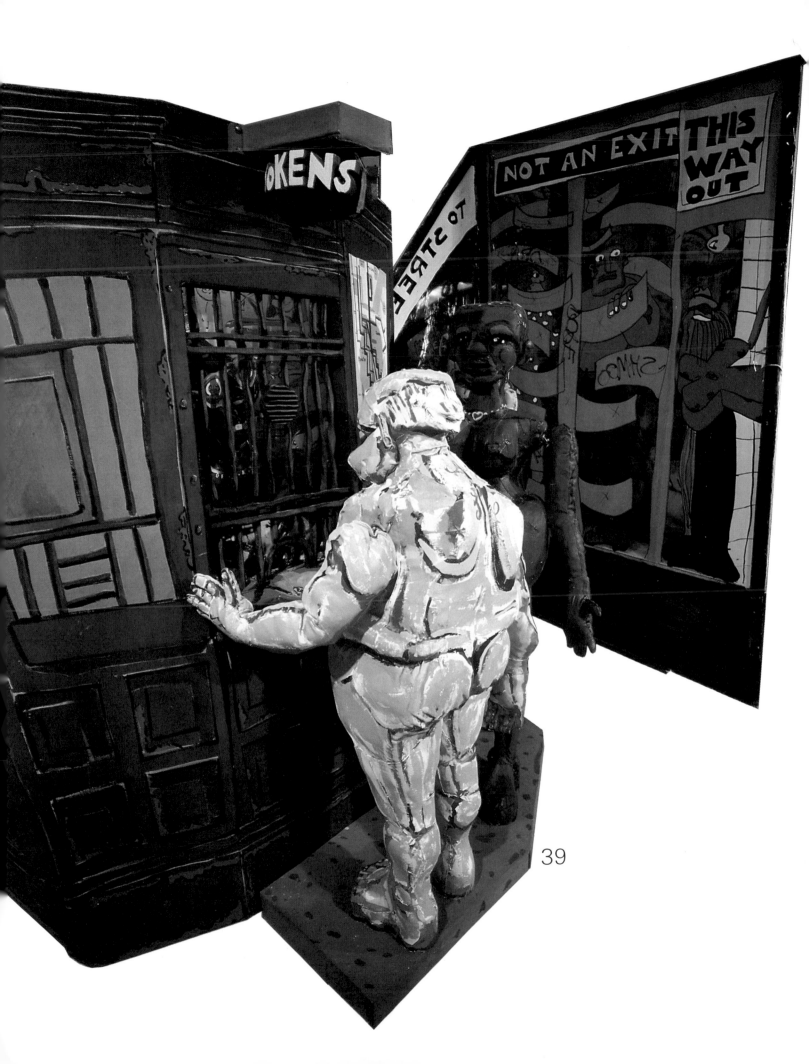

39

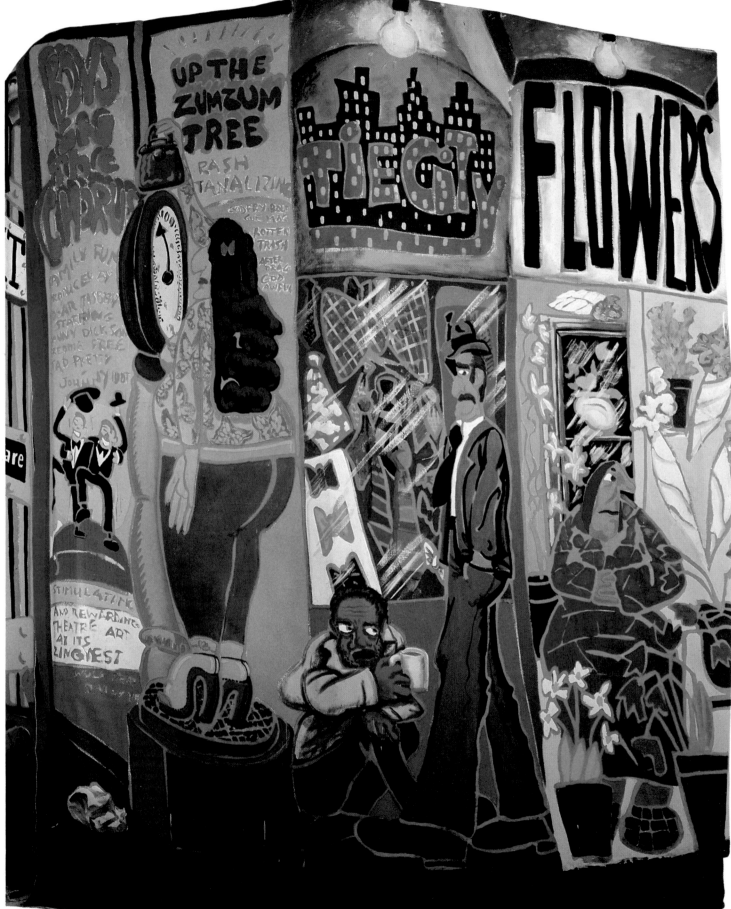

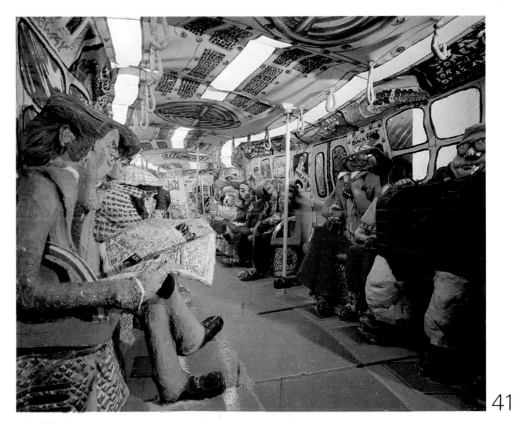

41

42

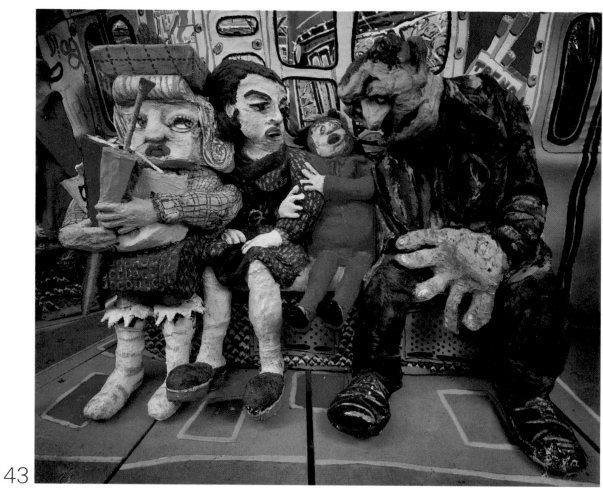

43

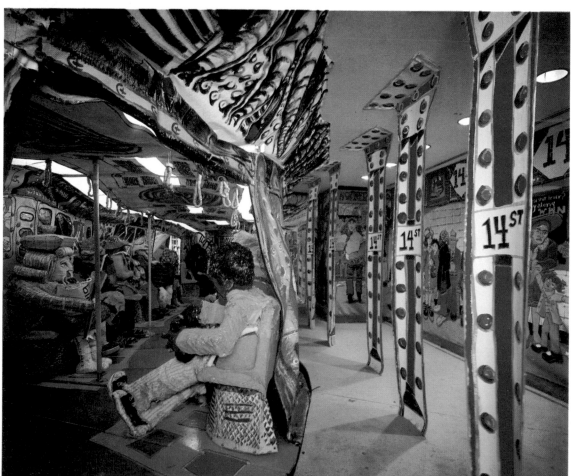

44

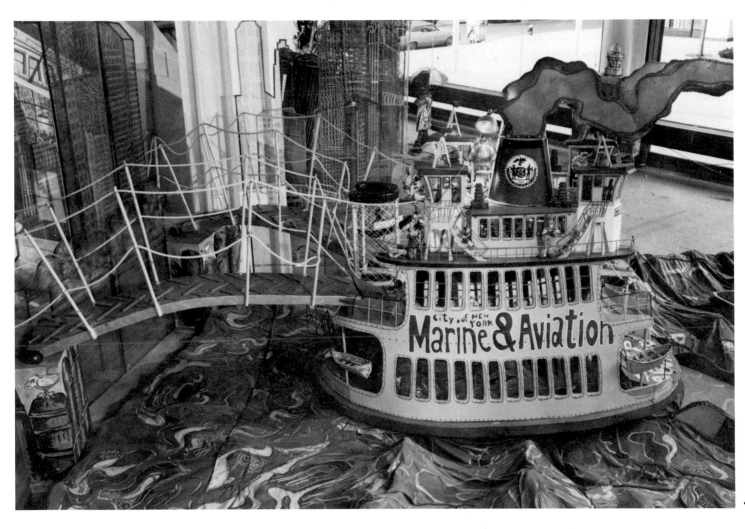

45

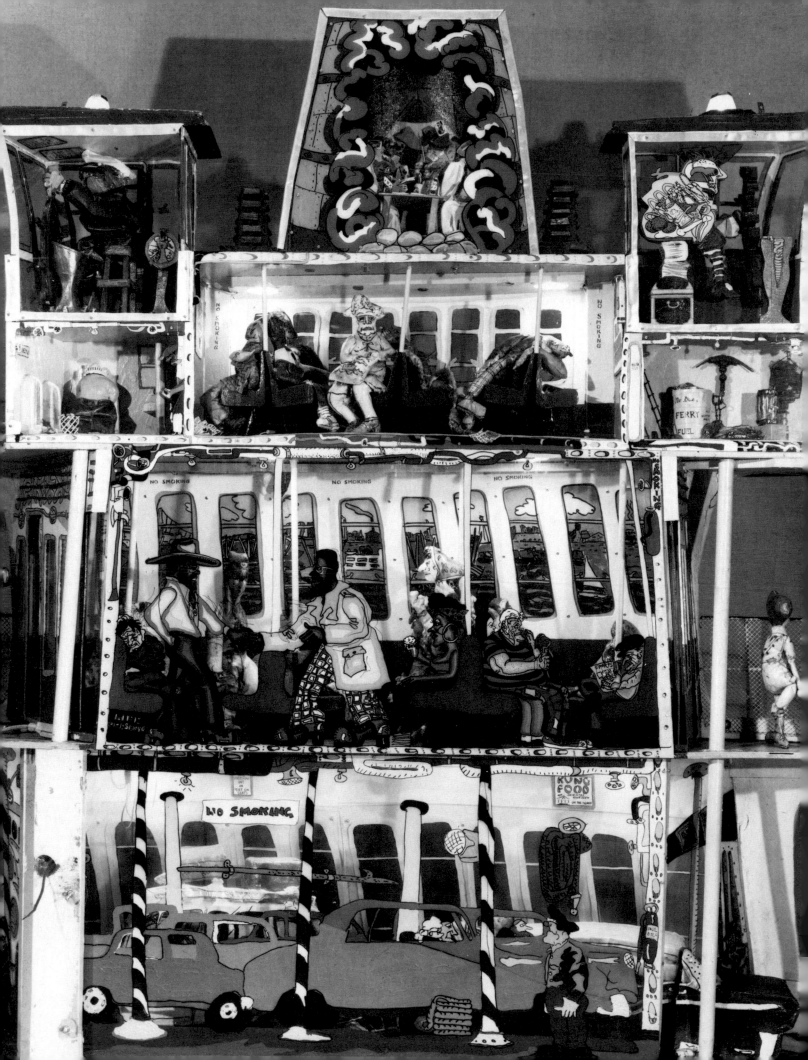

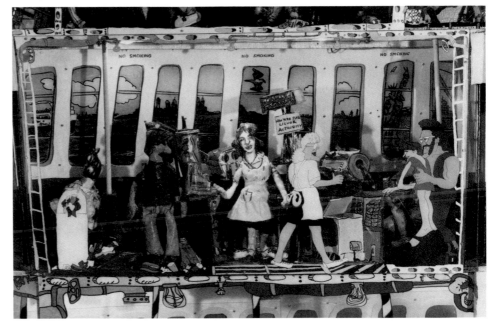

47

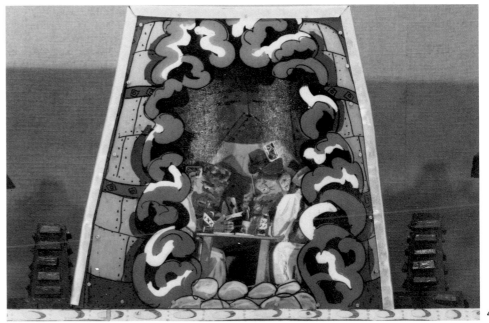

48

46

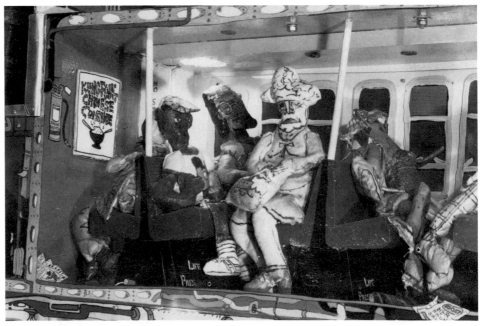

49

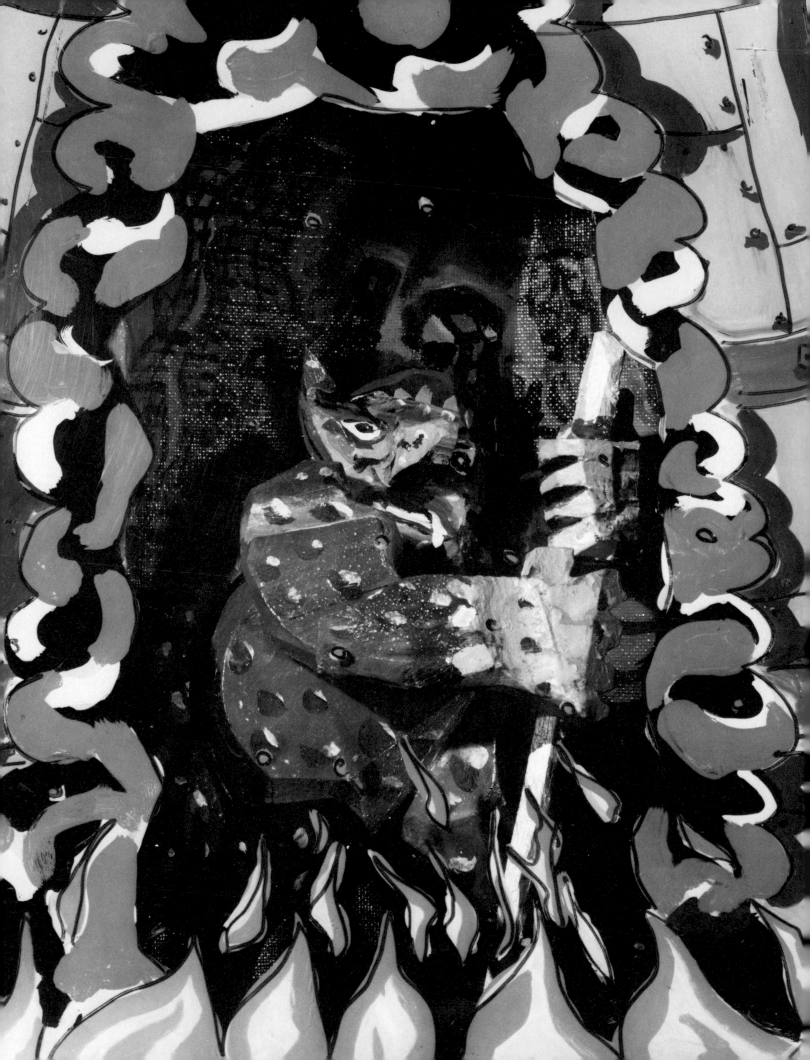

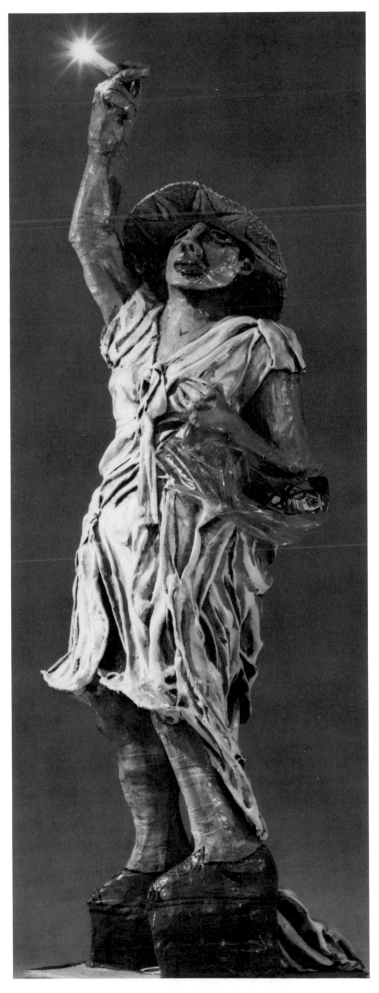

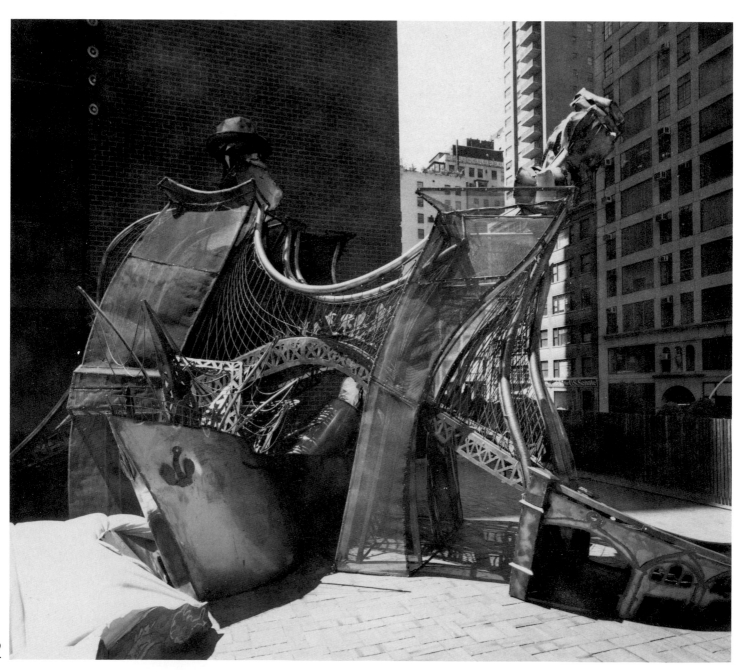

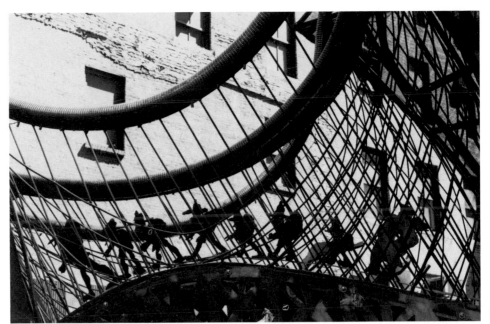

53

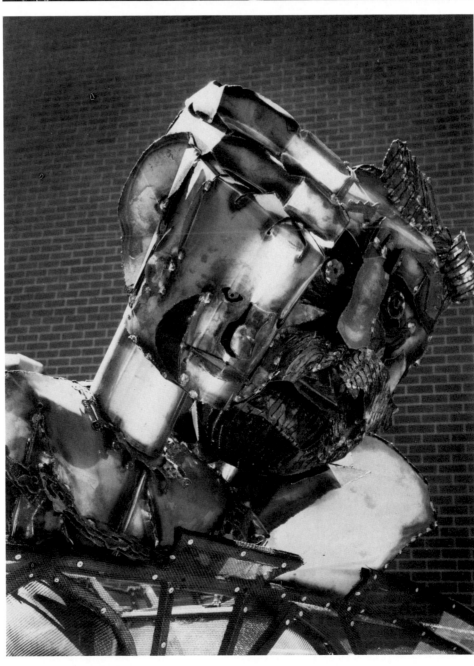

54

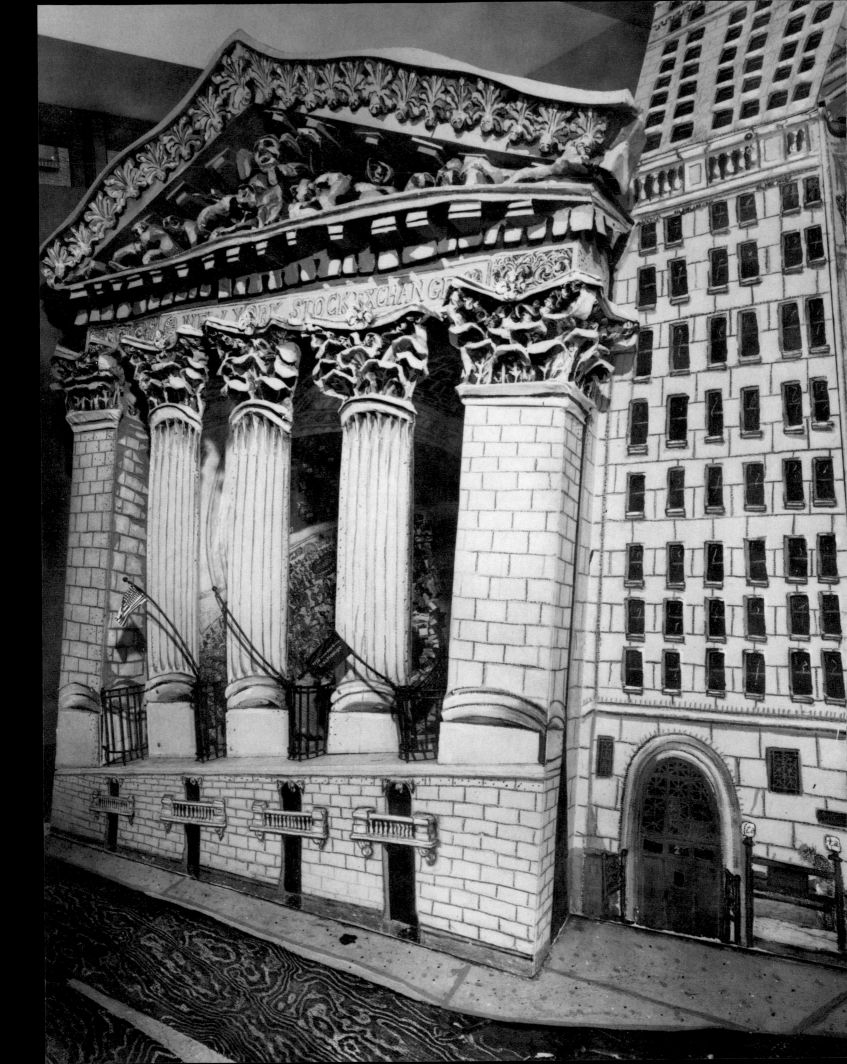

56

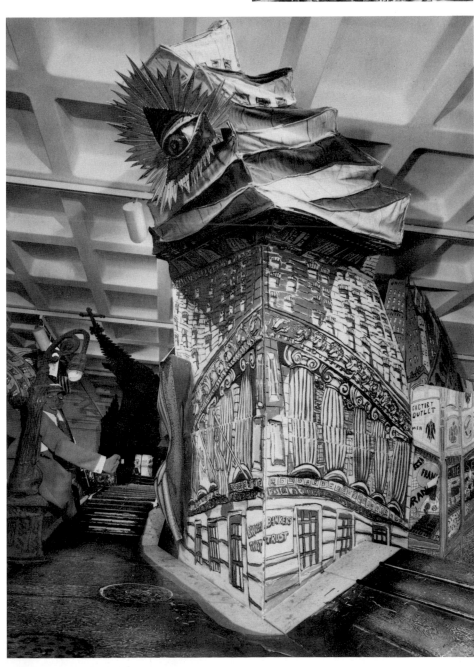

55

57

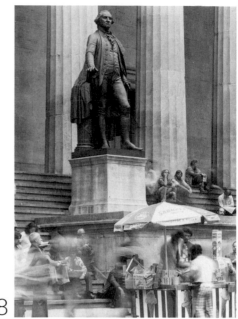

58

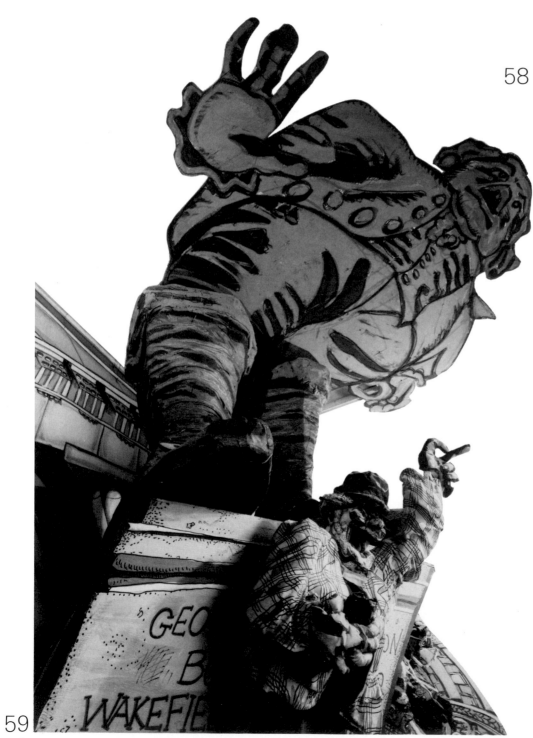

59

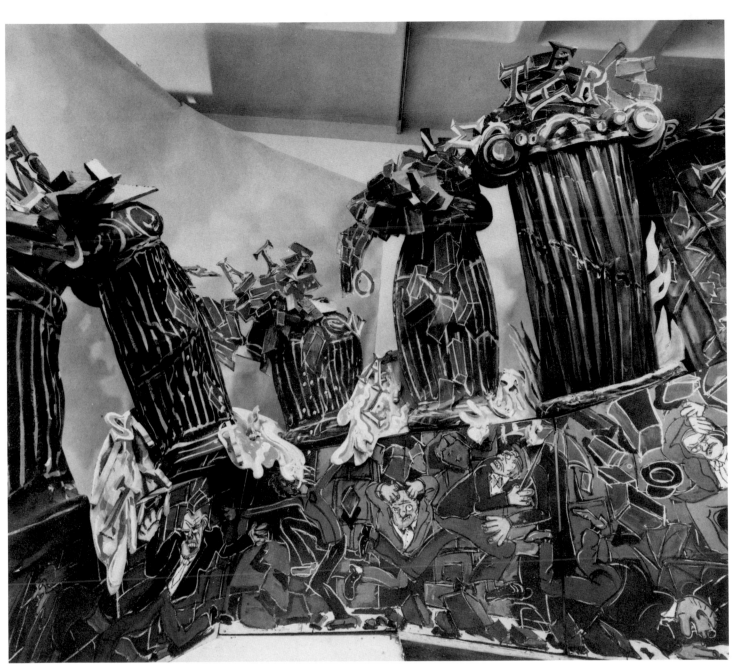

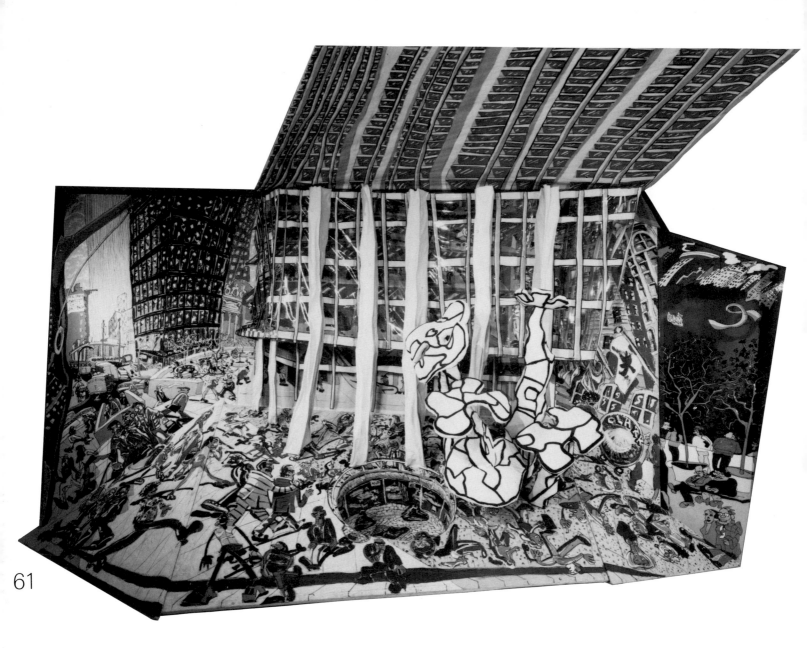

61

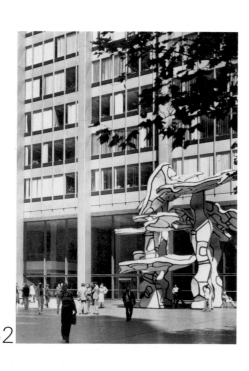

62

63

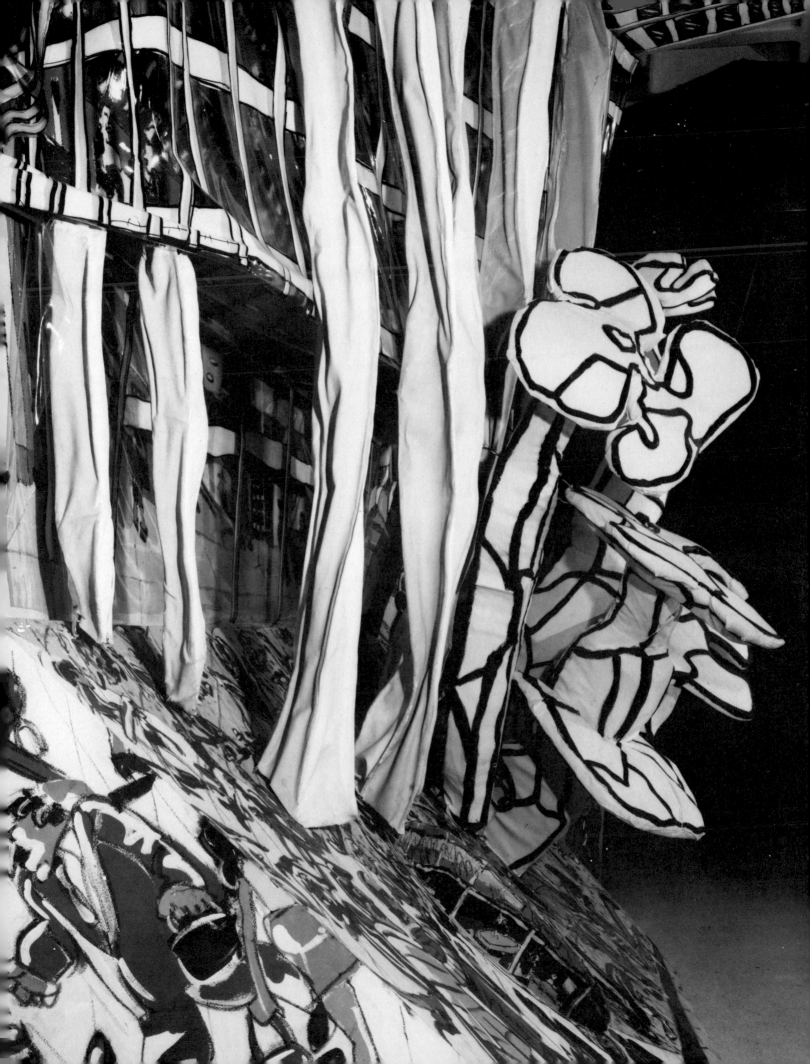

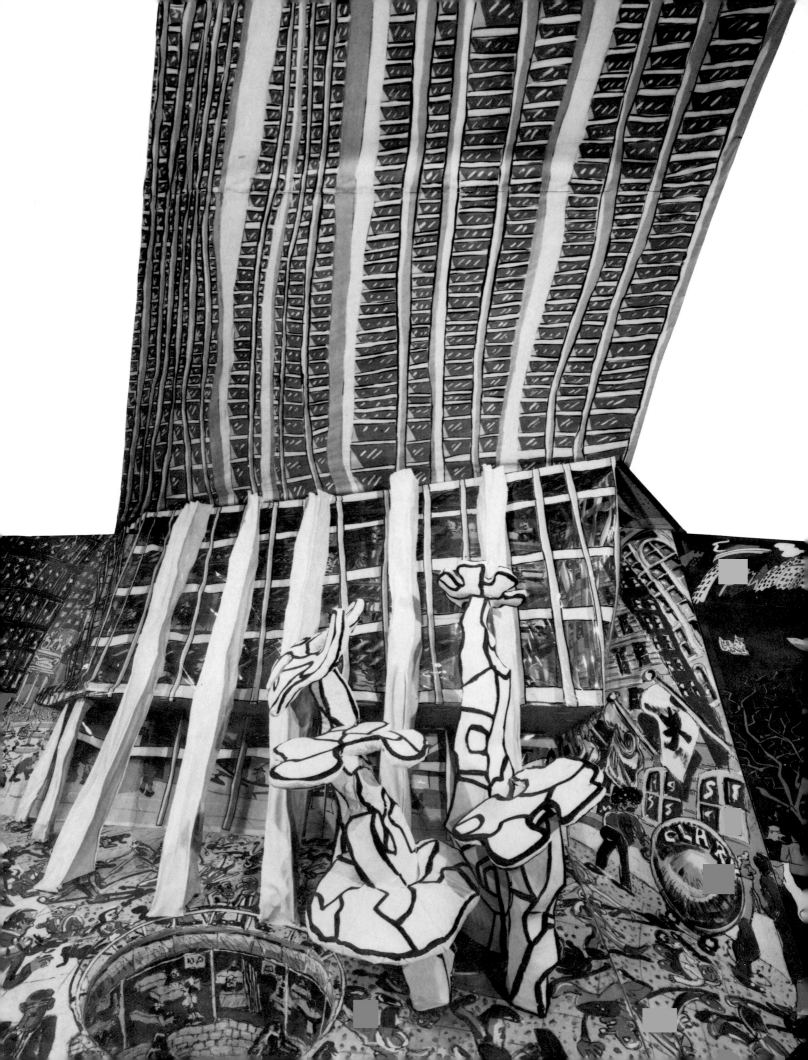

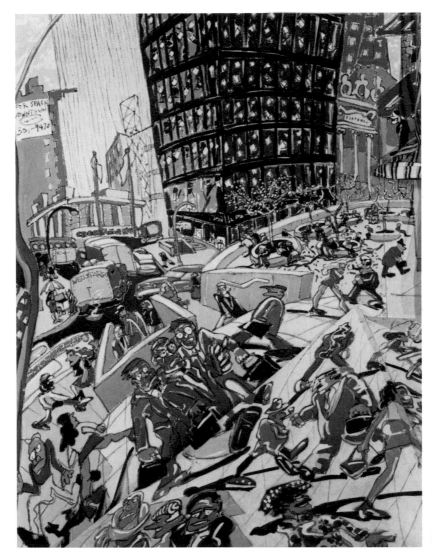

65

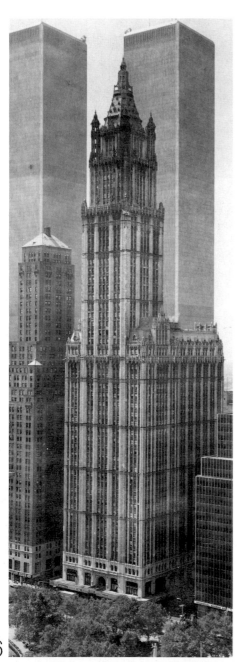

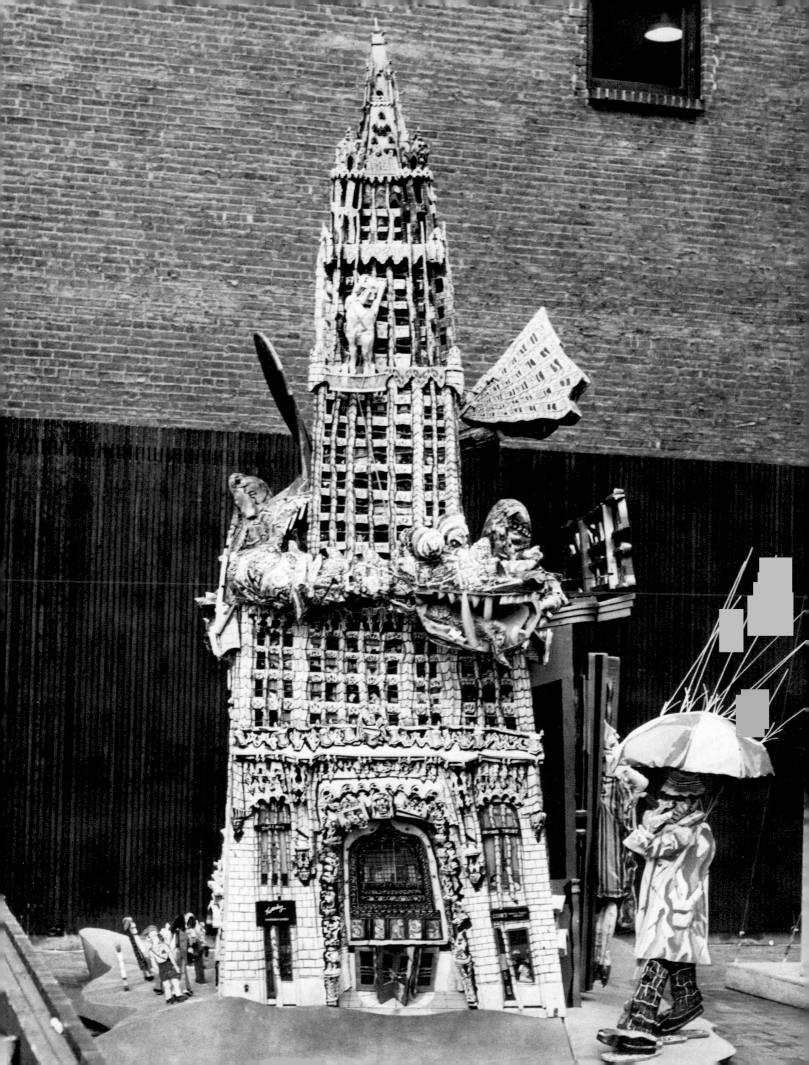

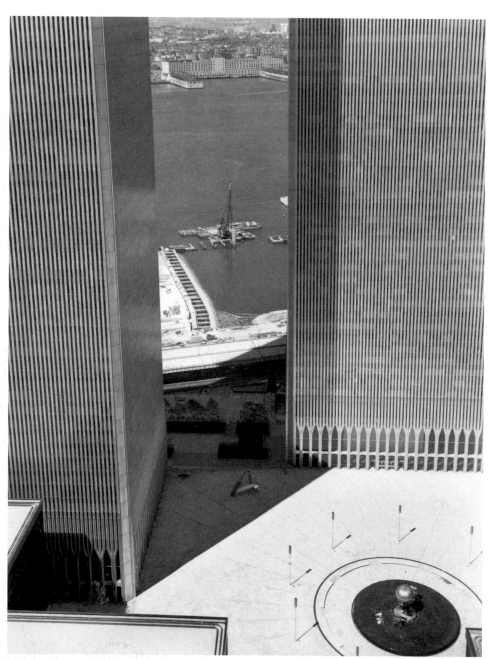

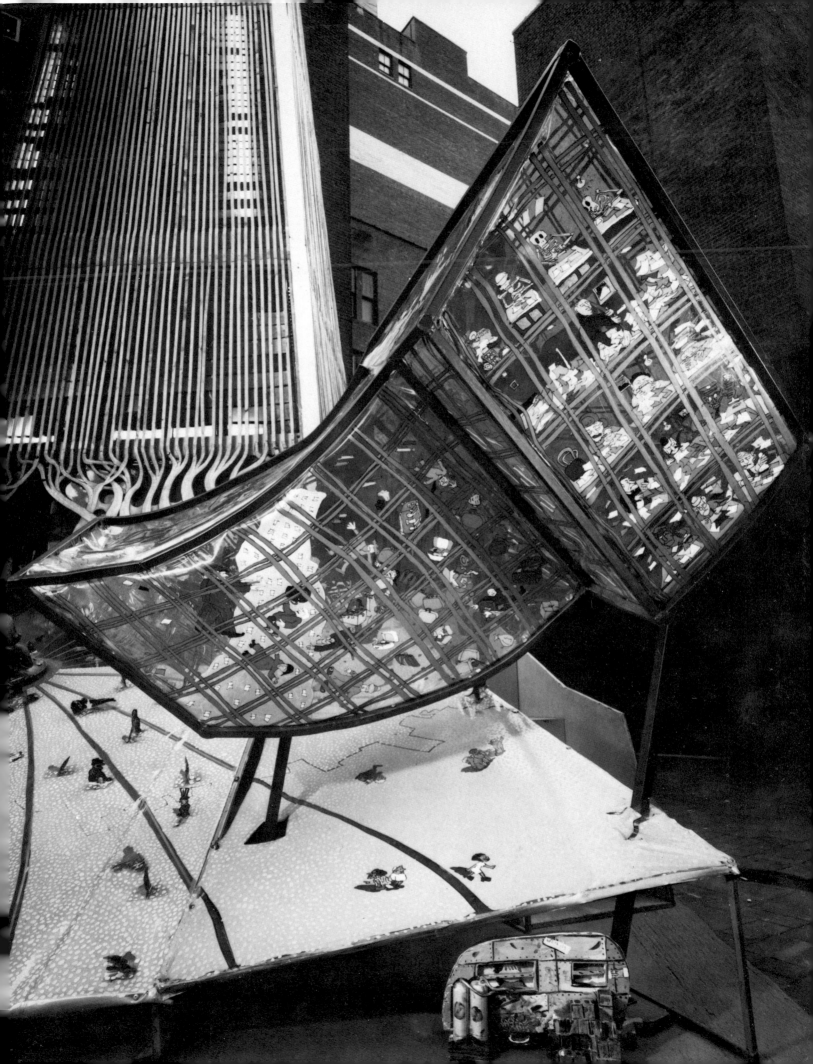

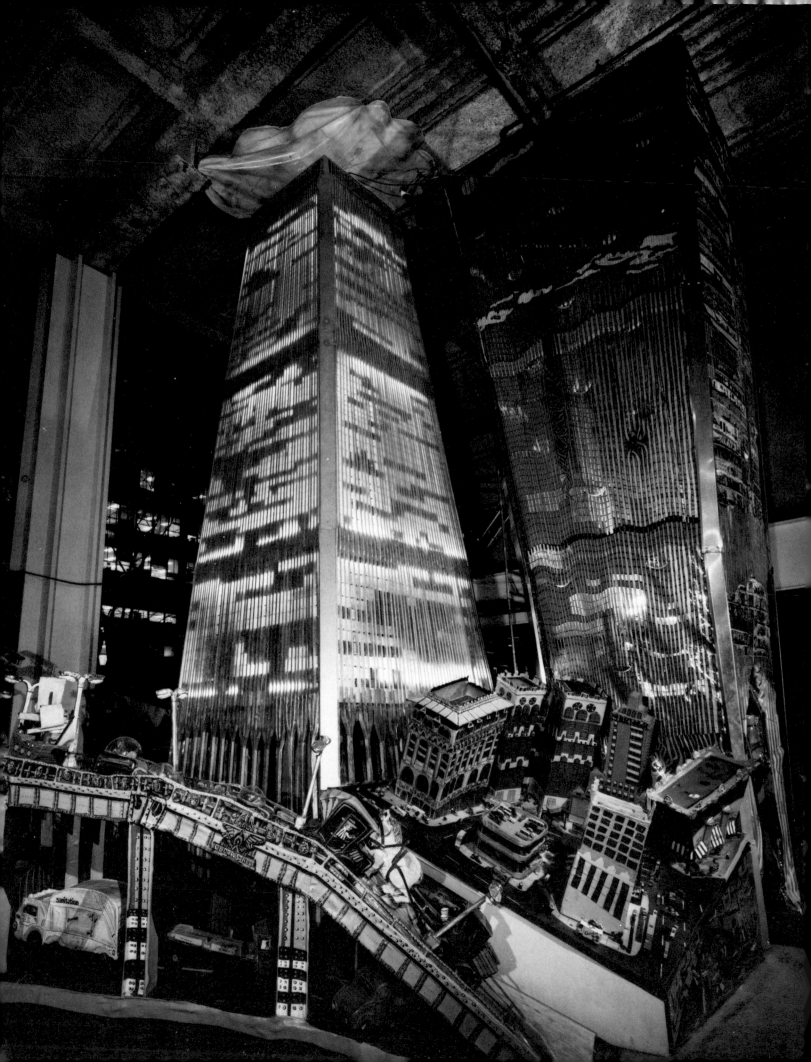

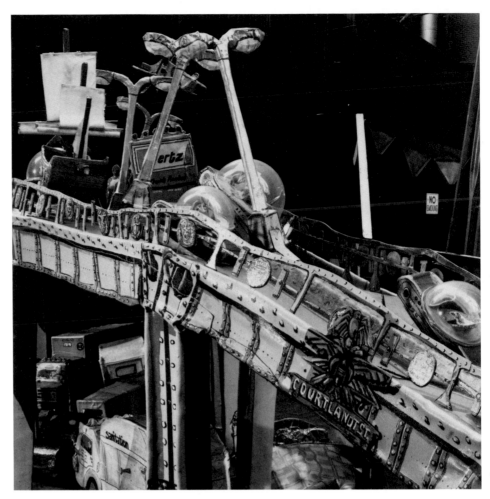

71

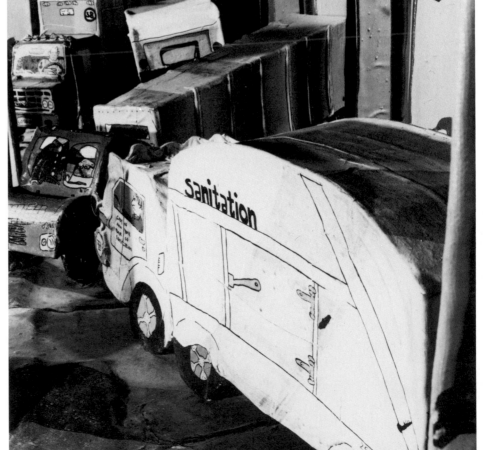

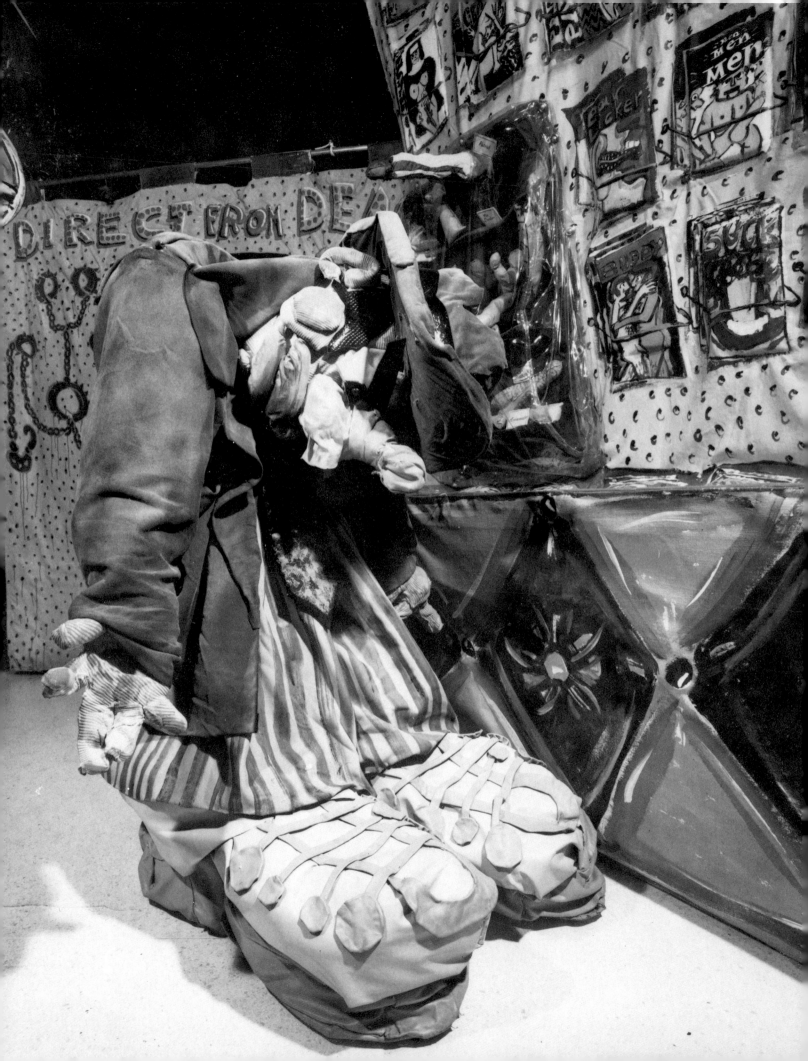

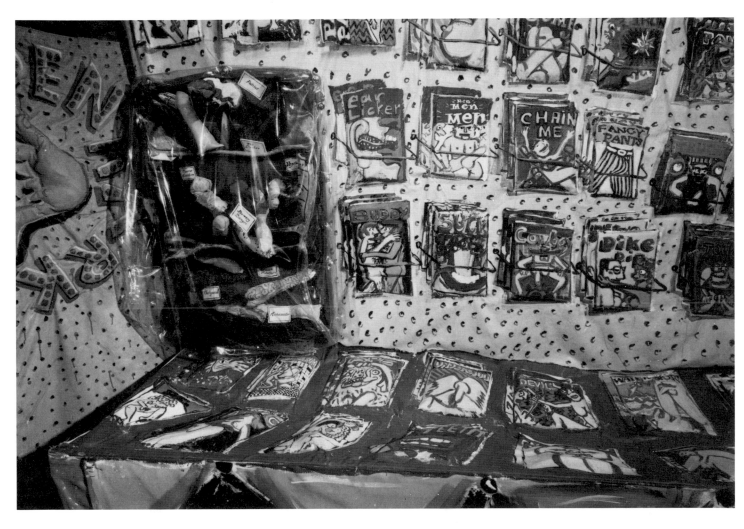

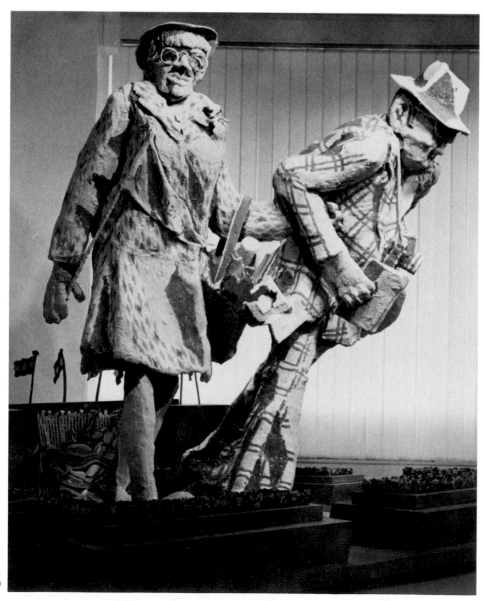

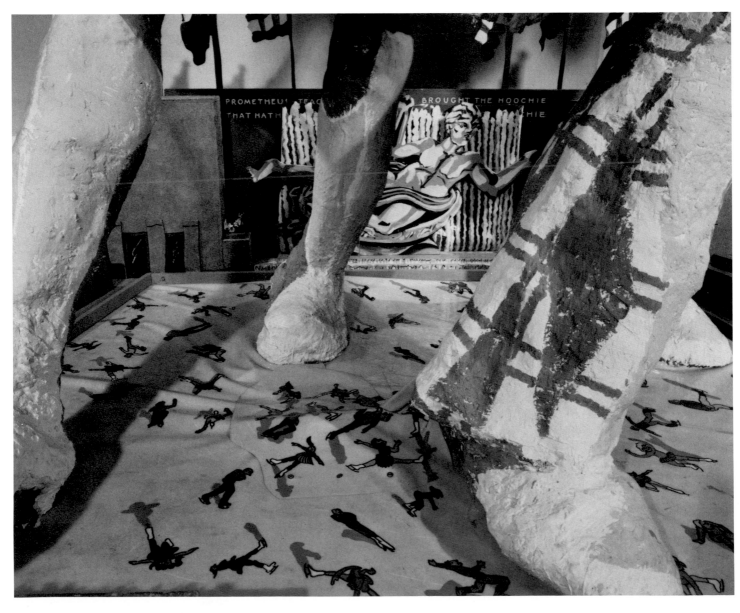

76

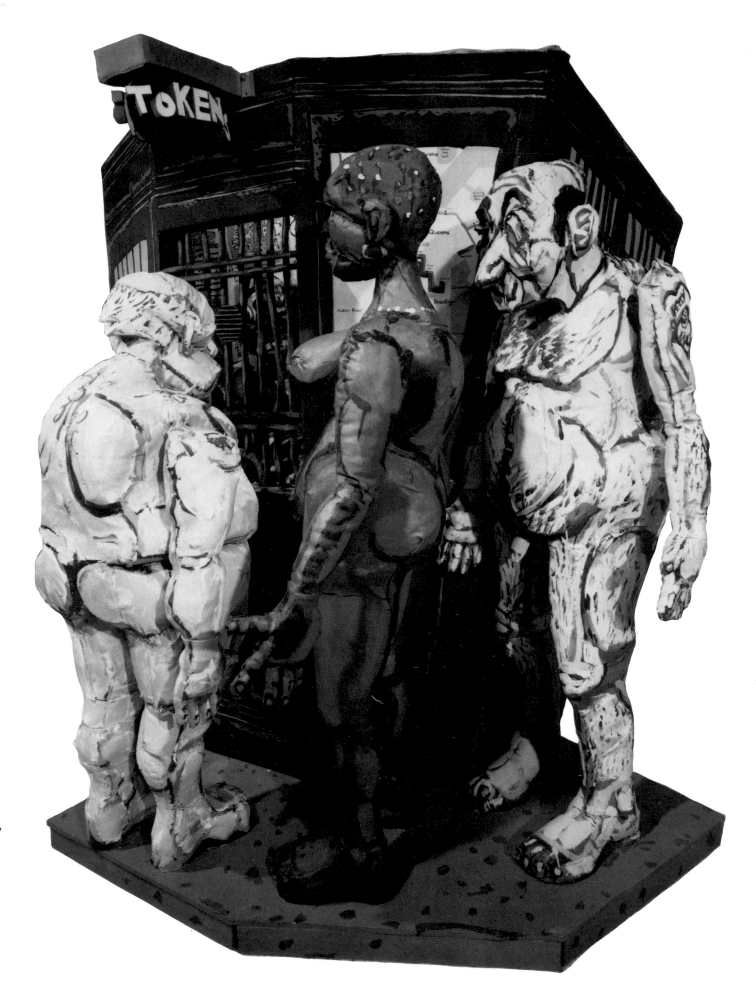

77

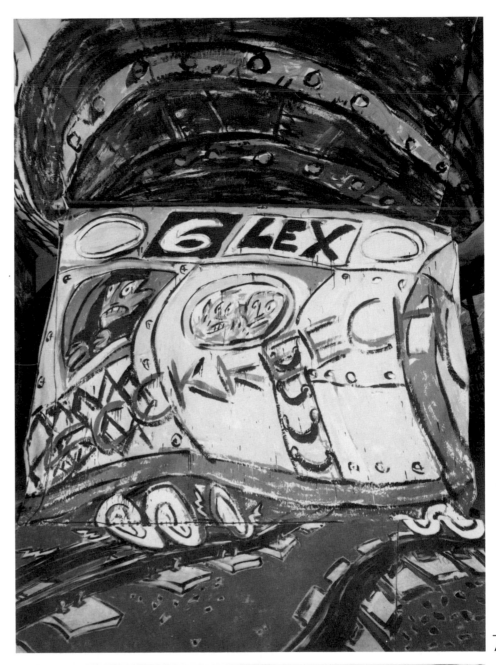

78

79

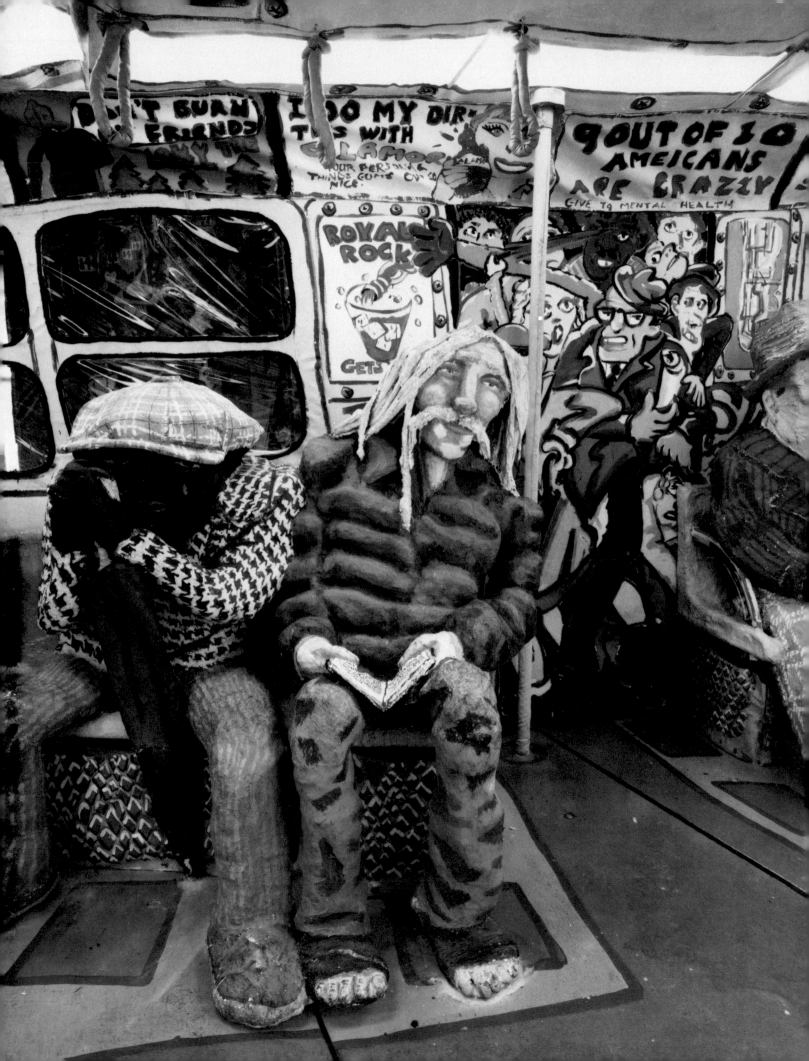

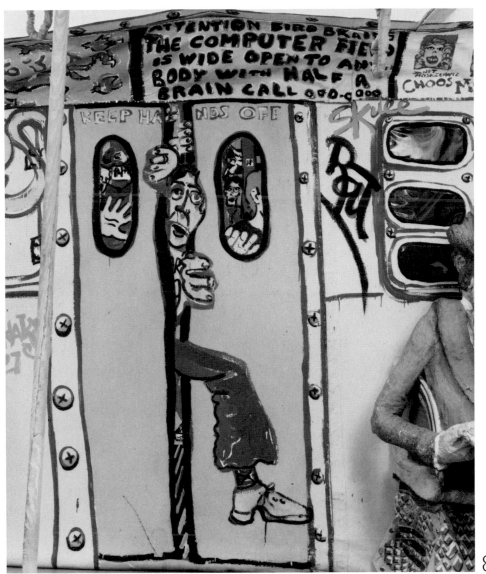

81

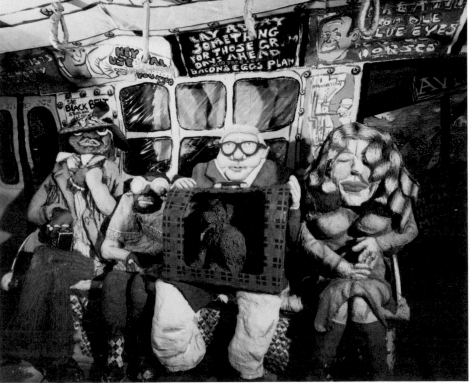

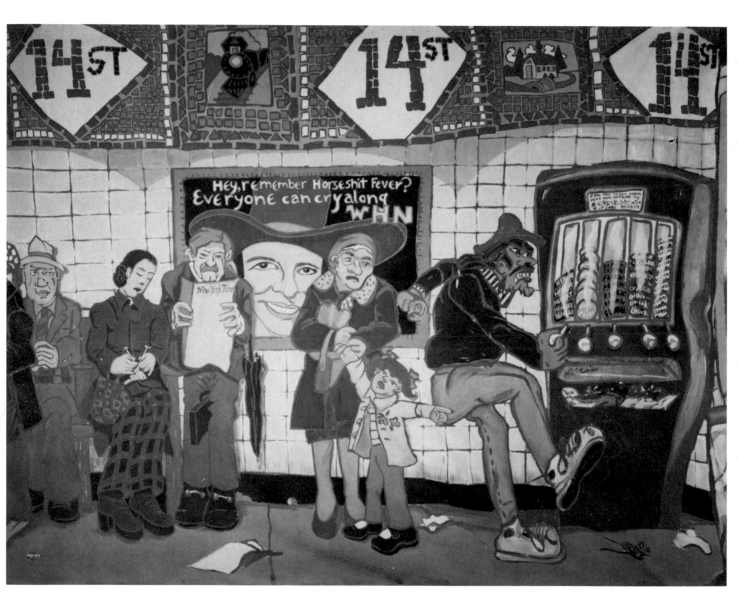

83

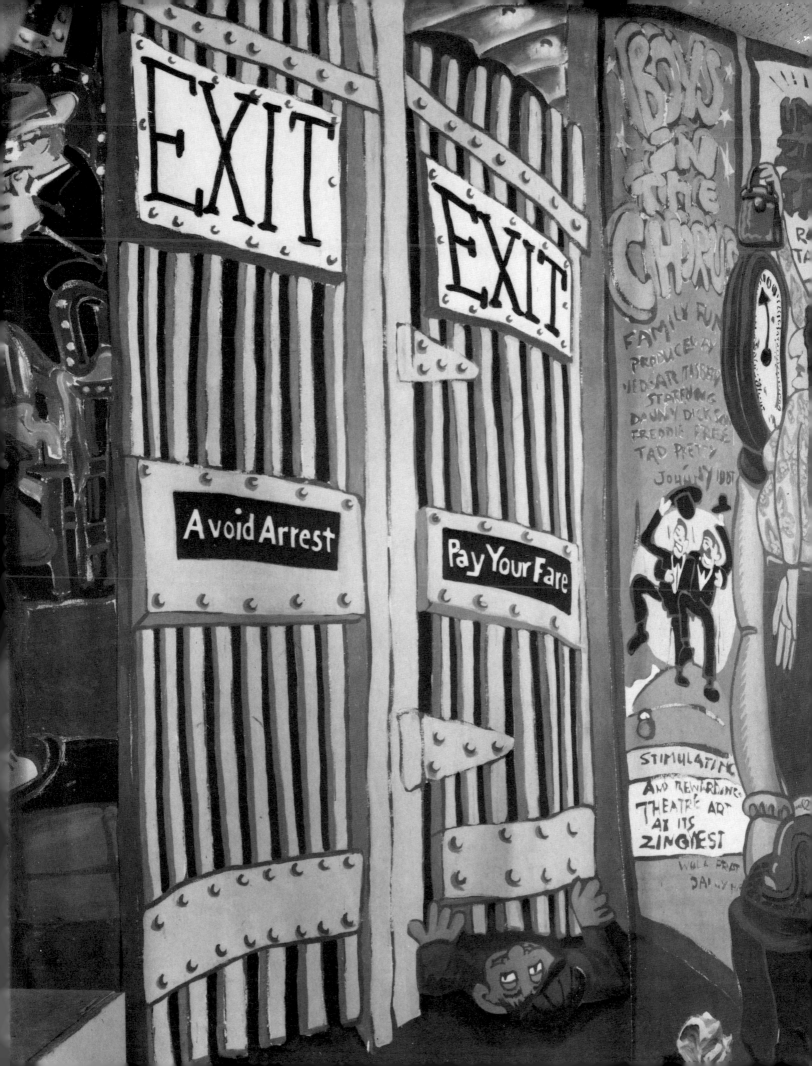